LITTLE KIDS AND THEIR BIG DOGS

REVODANA PUBLISHING
81 Lafayette Avenue, Sea Cliff, N.Y. 11579

ISBN: 978-1-943824-28-1

www.revodanapublishing.com

LITTLE KIDS AND THEIR BIG DOGS

BY ANDY SELIVERSTOFF

REVODANA PUBLISHING

WWW.REVODANAPUBLISHING.COM

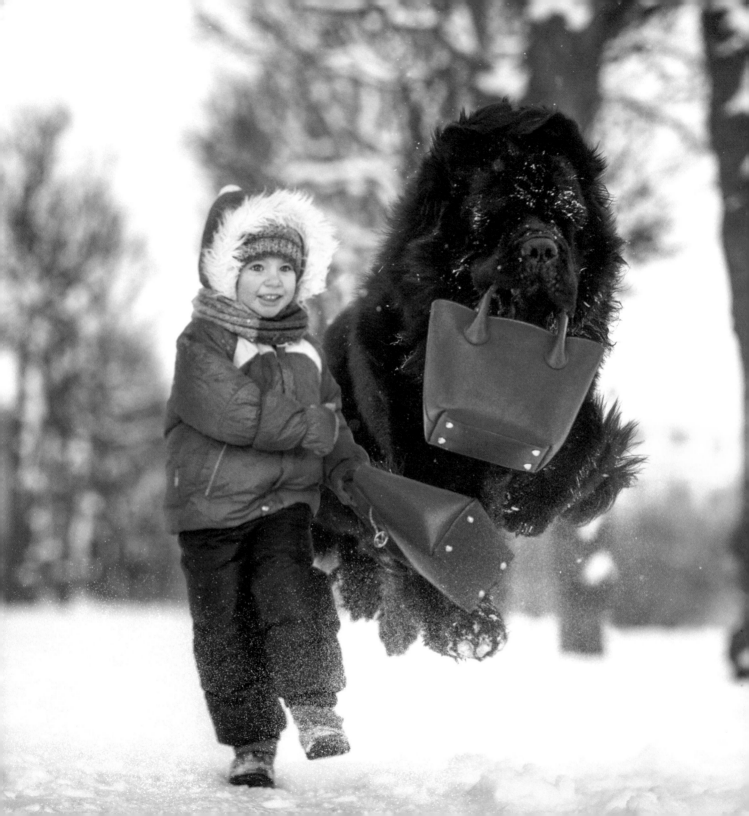

TABLE OF CONTENTS

INTRODUCTION

My name is Andy Seliverstoff, and I have always loved photography. Four years ago, I decided to take a leap of faith and become a professional dog photographer. Today, I can't imagine my life any other way.

The book you are holding started off — as many wonderful things do — as a sheer accident.

When good friends asked me to photograph their two-year-old daughter, they showed up at the park with their Great Dane in tow. I was blown away by the relationship between tiny Alice and gigantic Sean, and decided to incorporate him into the shoot.

Next came a photo session with a little boy named Theodore and Ringo the Newfoundland. As with Alice and Sean, those photos touched me deeply. When I posted them on Facebook, I discovered that lots of other people felt that way, too.

And so my *Little Kids and Their Big Dogs* project was born.

In my work as a dog-show photographer, I attend some of the biggest canine events all across Russia and Europe. That gives me access to a lot of gorgeous dogs, including some very rare breeds. And these dogs aren't just beautiful on the outside: They have amazing temperaments, and in particular the large and giant breeds have an innate gentleness that truly belies their stature.

But the appeal of *Little Kids and Their Big Dogs* goes beyond the size difference highlighted in the title. I think what has made these images so beloved is they capture the special bond between children and dogs. It's a

connection that doesn't need words. All the qualities we treasure — love, compassion, joy, trust, honesty and acceptance, to name a few — infuse the relationships between these two- and four-legged friends. You can see it in their gestures, in their faces. And I'm not just talking about the children.

In some ways, these little kids and their big dogs are an important reminder of the priorities that we adults sometimes lose track of in our daily lives. They transport us back to a time when we were innocent, and open, and understood the importance of a good romp in the snow, or a game of tag in the park.

When I shoot beautiful dogs at dog shows, capturing a historic win or big upset, I am a documentary photographer, always constrained by the literalness of the moment. But when I am shooting for *Little Kids and Their Big Dogs*, I am an art photographer, and I love the freedom that gives me: I can take several versions of a shot, from different angles and depths, capture the details of different interactions, and bring all those moments together in post-production to crystallize and amplify my vision. My ultimate goal is to telegraph my own emotions and interpretation of the moment. I want you to see what I've seen, to feel what I felt taking a photo. And I hope I've succeeded.

Each series of images in this book is accompanied by a short story about the dogs and children featured in it. Some of the stories are a bit fantastical, as I imagine the inner lives of the dogs and the younger children. But, like my photographic compositions, they are true to the connection between the children and the dogs.

My deepest thanks to Julia Veshkelkaya for penning these mini-vignettes, and to Katarina Zaslavskaya for translating them from Russian into English. And, of course, to Anna Malsub, who was invaluable in helping develop this book's cover shot. She found the gorgeous Komondors, arranged the shoot and provided the best child model we could have asked for — her son Arthur!

I hope you enjoy the beautiful alchemy of *Little Kids and Their Big Dogs*. As for me, I am heading back to the place I love best — behind that magic lens.

NANNY KNOWS BEST

Alice is a little girl who lives with her mom and dad in Saint Petersburg, Russia. Ever since she was a baby, people in the street have been turning around to look at her.

The reason is her big friend — a Great Dane named Sean.

Sean always accompanied little Alice while she slept in her baby carriage, and now he patiently waits while she swings in the park. And Alice likes to watch Sean practicing with his handler and competing in dog shows. But most of the time you can find them walking along the bank of a river, along an empty beach, or in a glade in the woods, just enjoying each other's company.

Alice will be two years old soon — two years of a tender love story between a big dog named Shangar Terra Alano and his little girl Alice.

"Isn't she scared of that dog?" asks a passerby, as she notices Sean sitting beside Alice.

Alice looks at Sean. She isn't able to talk yet, but if she could, she would certainly answer that she is scared of that strange woman — not the dog.

Sean doesn't need words to understand Alice. He comes closer and sits motionless beside her. When Sean is nearby, nothing scares Alice.

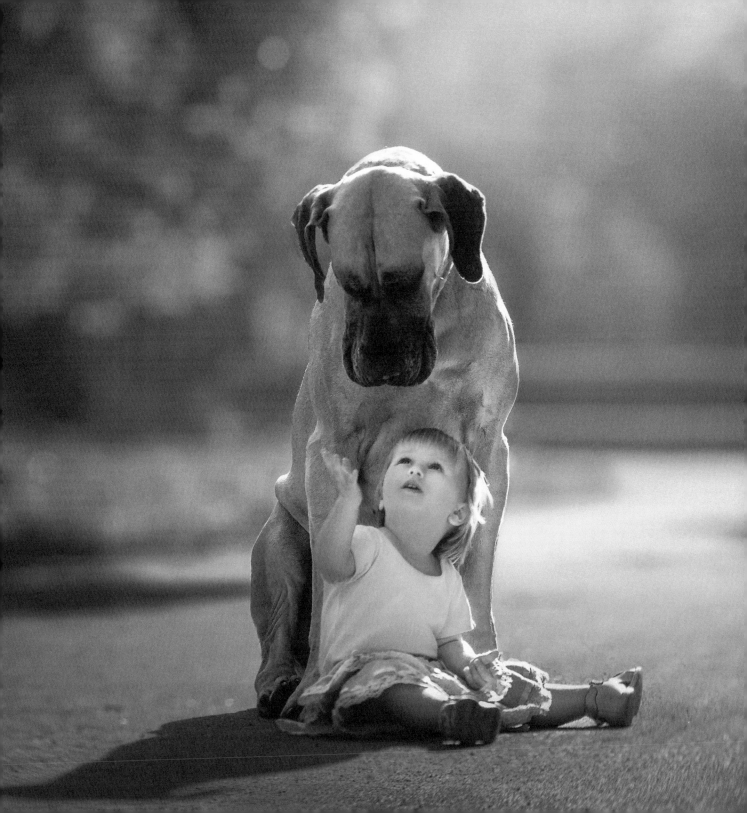

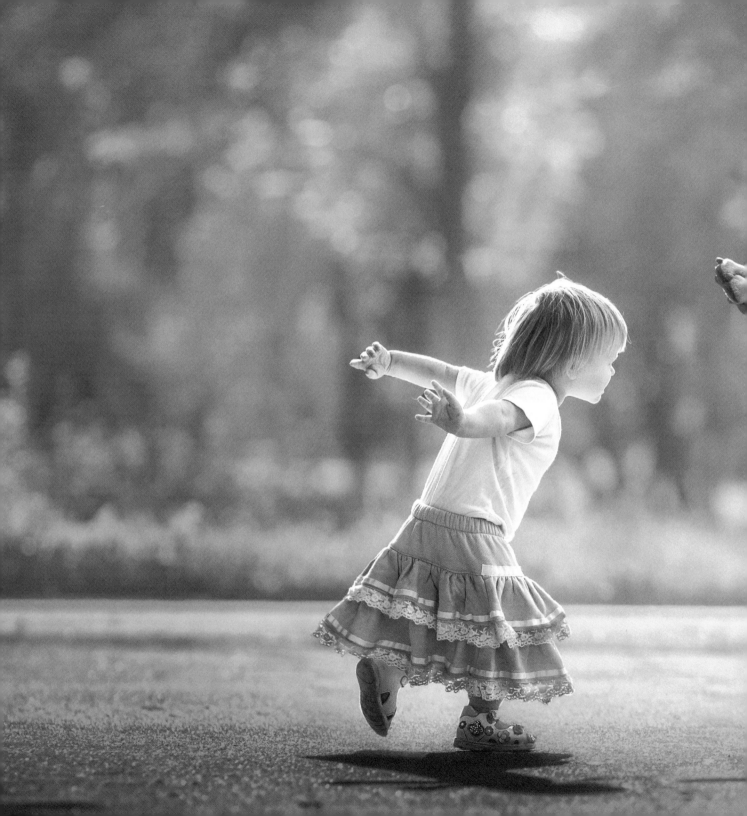

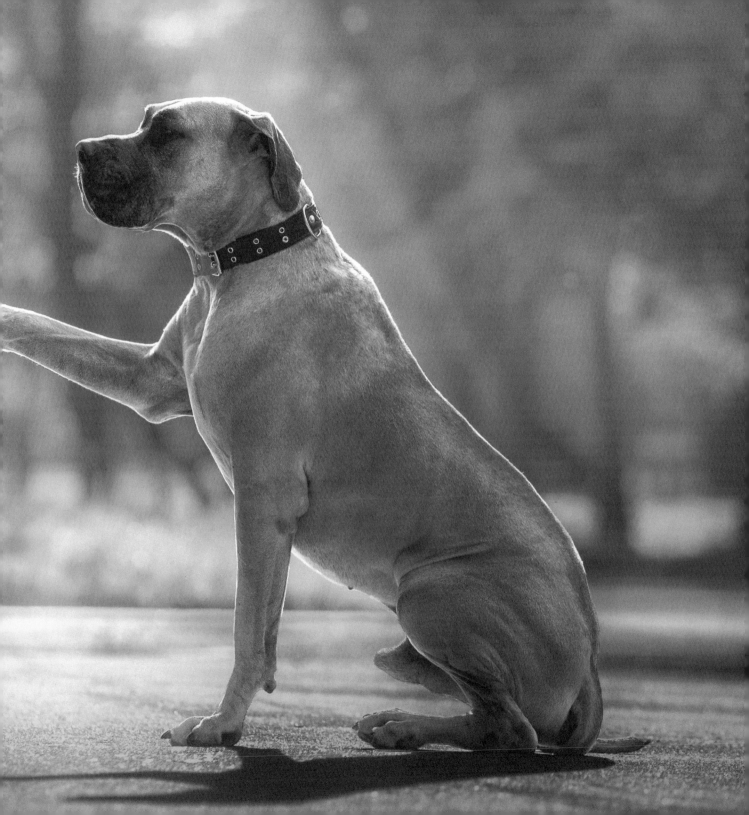

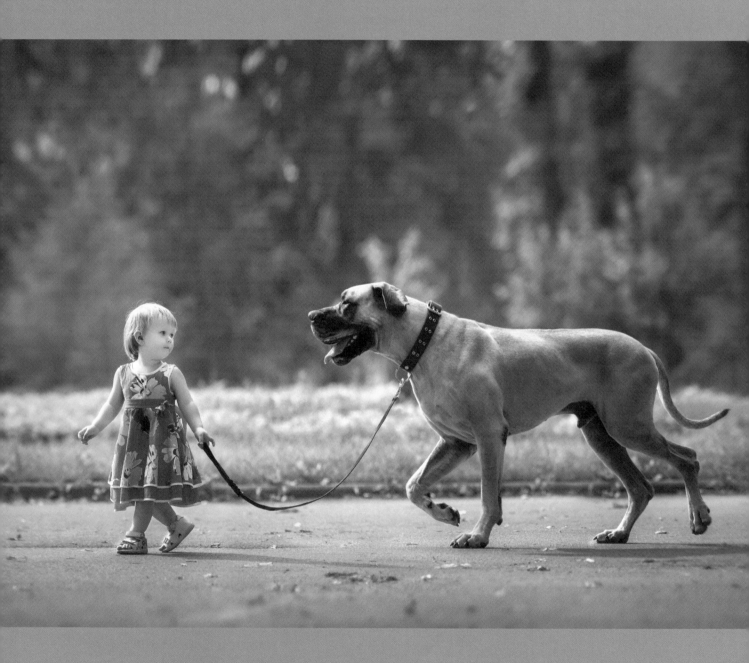

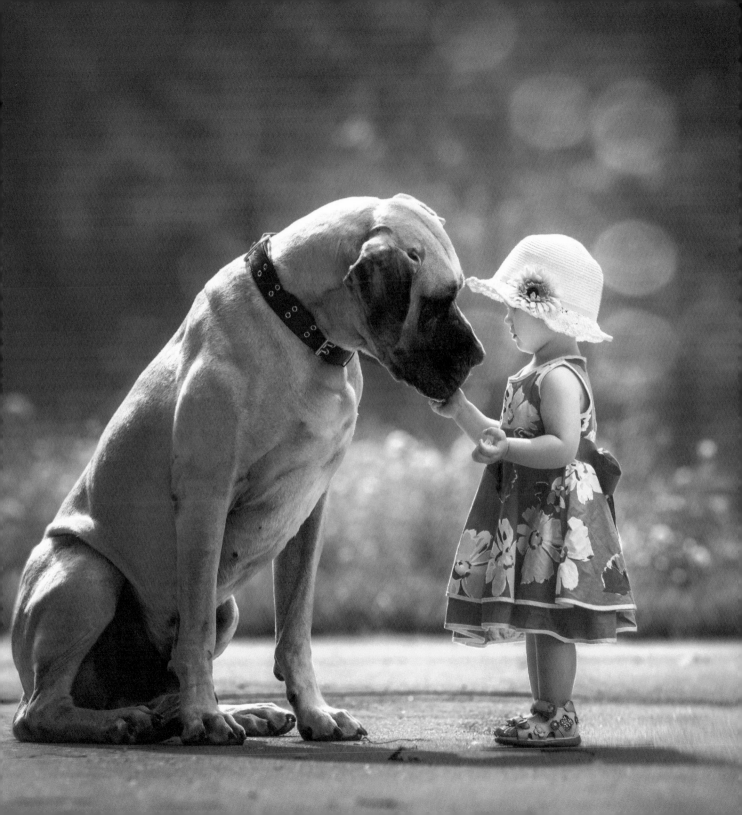

THE LIFEGUARD

"Tell me, Ringo, are you a lifeguard?" little Theodore asks his Newfoundland friend.

"Yes," Ringo nods seriously. After all, water rescue is what Newfoundlands were bred to do.

"So if someone is drowning, you get him out of the water? And if someone is lost, you lead the way?"

Ringo nods again. "It will be better if you tell me what you're really asking."

Theodore smiles shyly and pokes the earth with the toe of his boot. "Well, I just wanted to go to the river, where we were walking with Mom and Dad on the weekend. And I don't know the way."

Ringo shakes his head. "You know your parents don't allow you to play there alone."

"Please! I won't be there alone, but with you, and you're a lifeguard," says the boy, his huge eyes getting rounder. "And I won't go near the water, I promise."

"You're a little dodger," Ringo grumbles. The boy hugs Ringo's big neck, and fingers his thick, black fur. "Okay," the Newfoundland finally concedes. "But we need to get your mom's permission, and you must promise that you will obey me."

They put a few sandwiches into a basket, pack some water, and hit the road. The track to the river is winding, and the boy marvels at how Ringo always chooses the right path through the thicket of bushes under the spreading lime and maple trees.

Soon Theodore and Ringo come to the river. The boy keeps his word: He doesn't go near the water, though he really wants to. He just sits beside his friend and watches the shadows of the clouds floating on the water's surface.

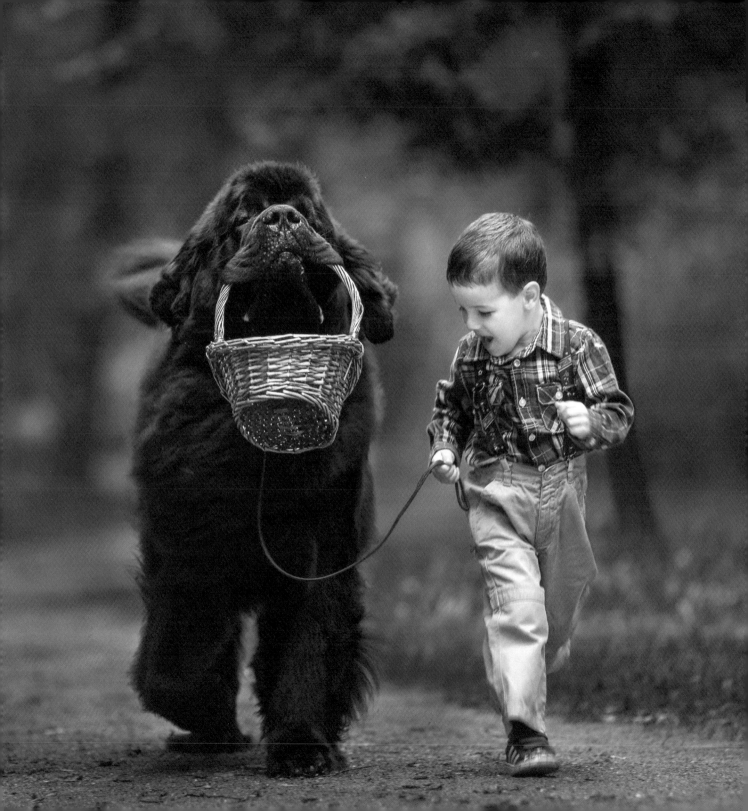

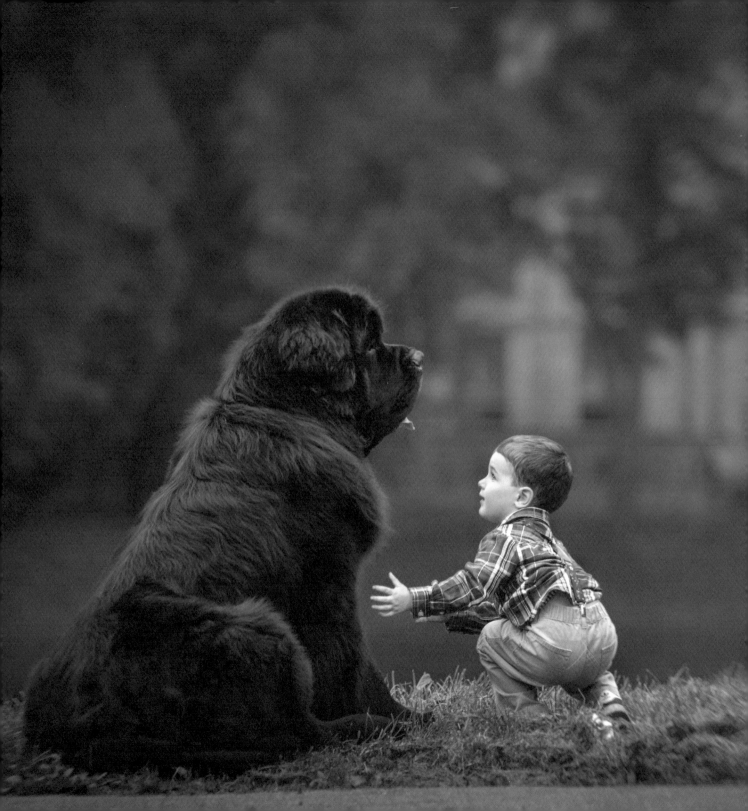

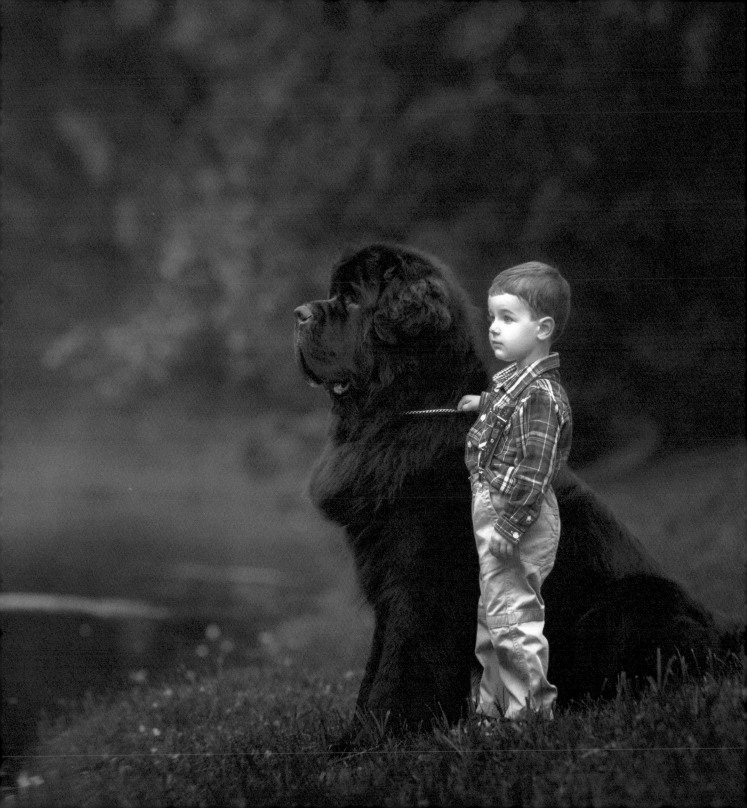

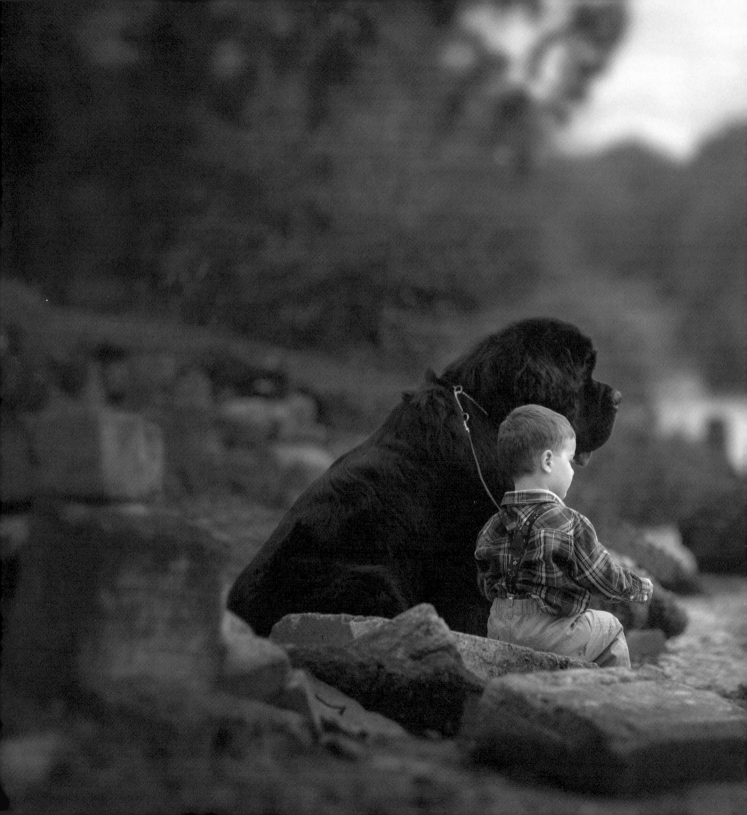

READY FOR MY CLOSEUP

When Alexandra's father gives her his old camera, she can't wait to learn photography. But her parents are too busy to pose for her, and Alexandra is soon bored with shooting houses and trees and sky.

Then, on a walk, Alexandra's Great Dane, Zarmina, volunteers herself. "Sasha, if you want, I'll be your model." The girl is instantly delighted, then shakes her head sadly. "But Mom says you're six, and that's really old for a Great Dane."

Zarmina laughs and licks the girl on the cheek. "Well, I'm not that fragile. I won't jump and run, of course, but I can sit down or stand up."

Alexandra claps her hands. She photographs Zarmina all day against the backdrop of the most beautiful places around the house. That evening, Alexandra shows her parents the photos on the computer screen. Every few minutes she runs up to Zarmina on the couch and hugs her.

"You're the best fashion model," Alexandra exclaims. "Tomorrow we'll go to the lake, where our photographs will be even more beautiful!"

And Zarmina smiles, because she remembers that not so long ago, Alexandra was quite an amusing creature, so tiny lying there in her crib, not knowing how to walk or sit. And one fine day, perhaps the most important day in Zarmina's life, the baby held out her hand, grabbed Zarmina's cheek between her fingers and smiled, and with her huge blue eyes looked straight into the soul of her dog.

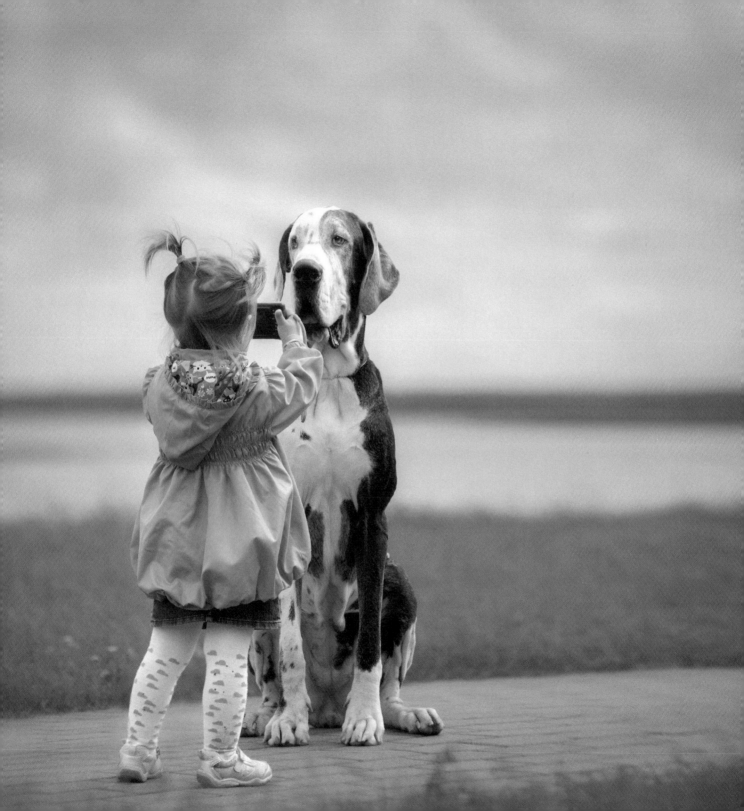

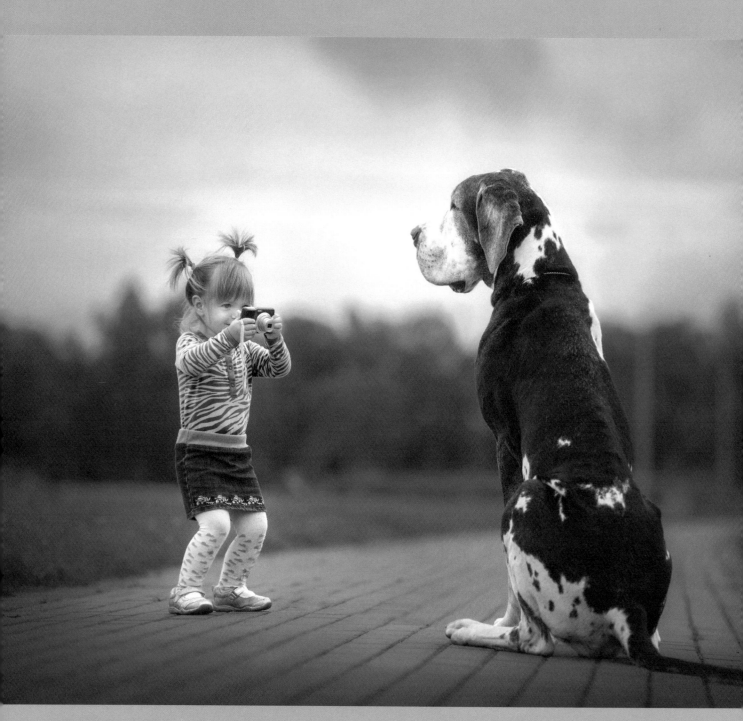

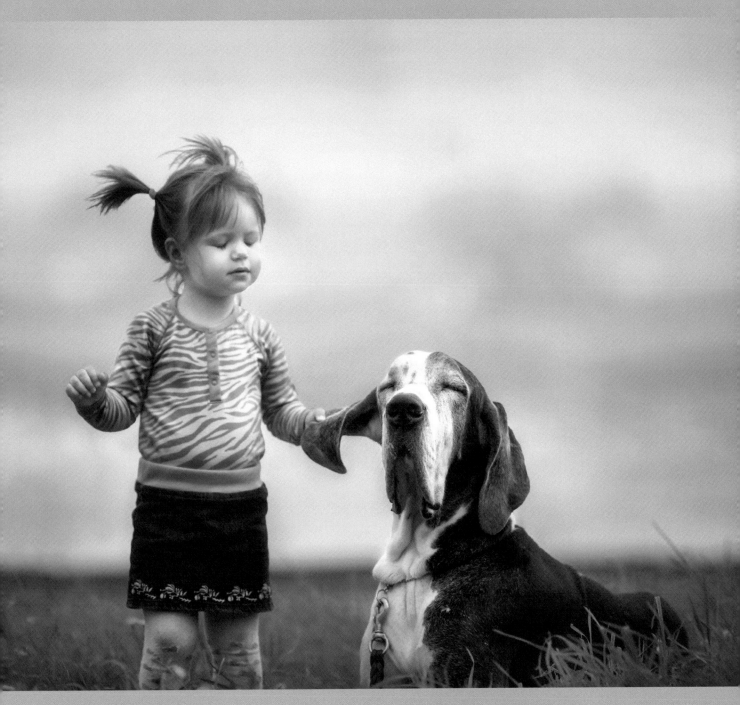

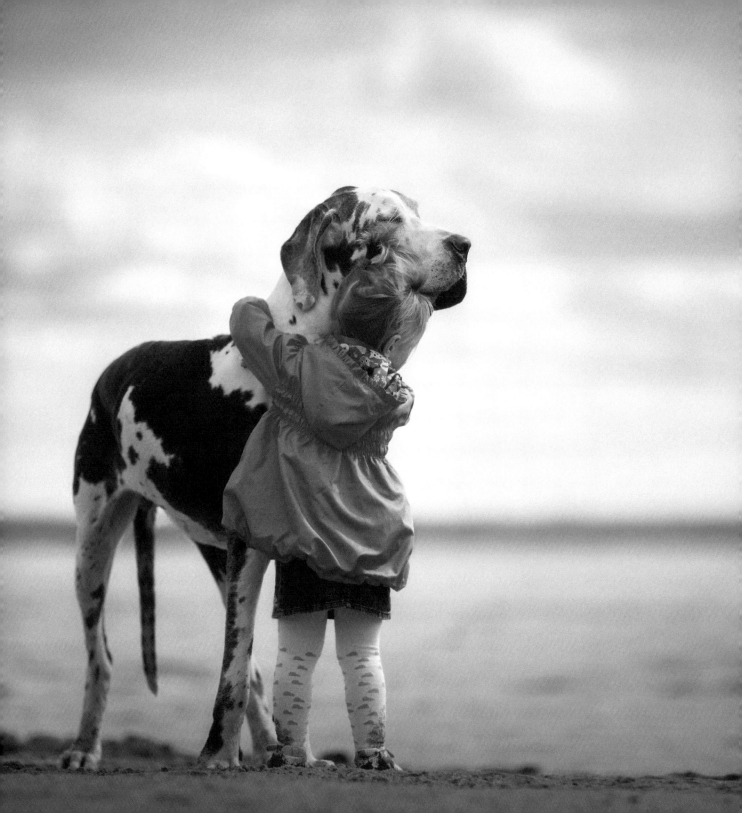

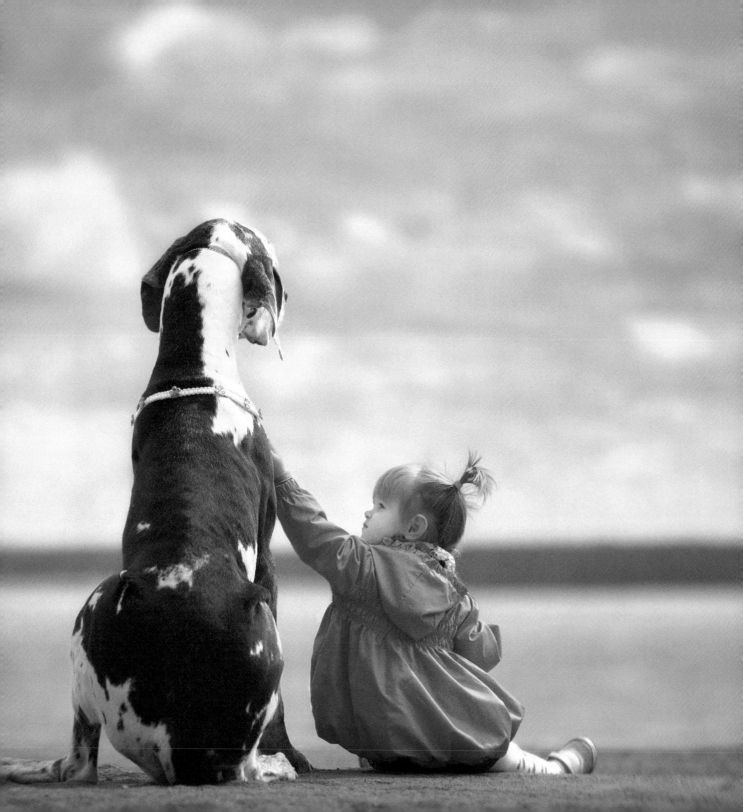

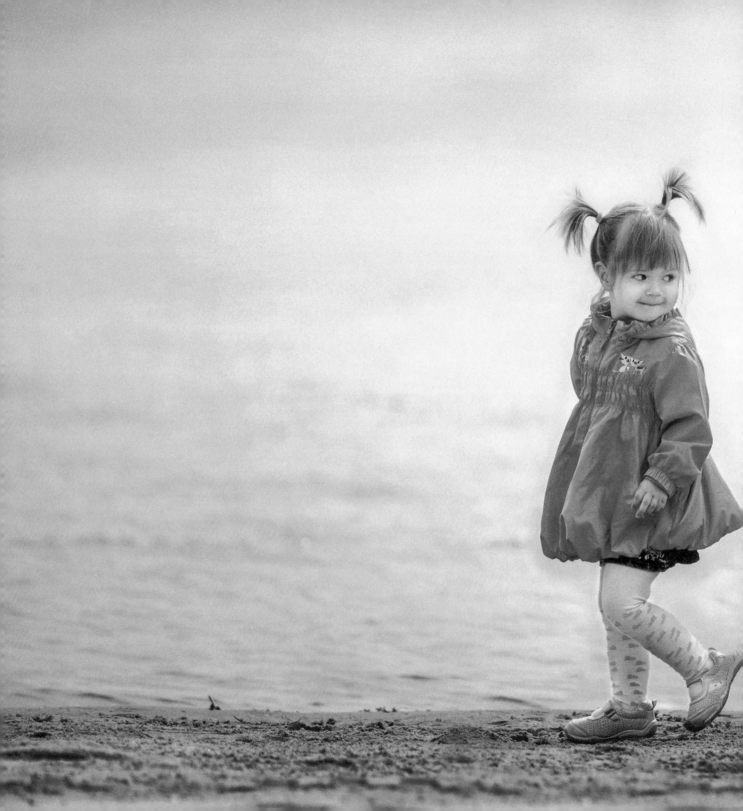

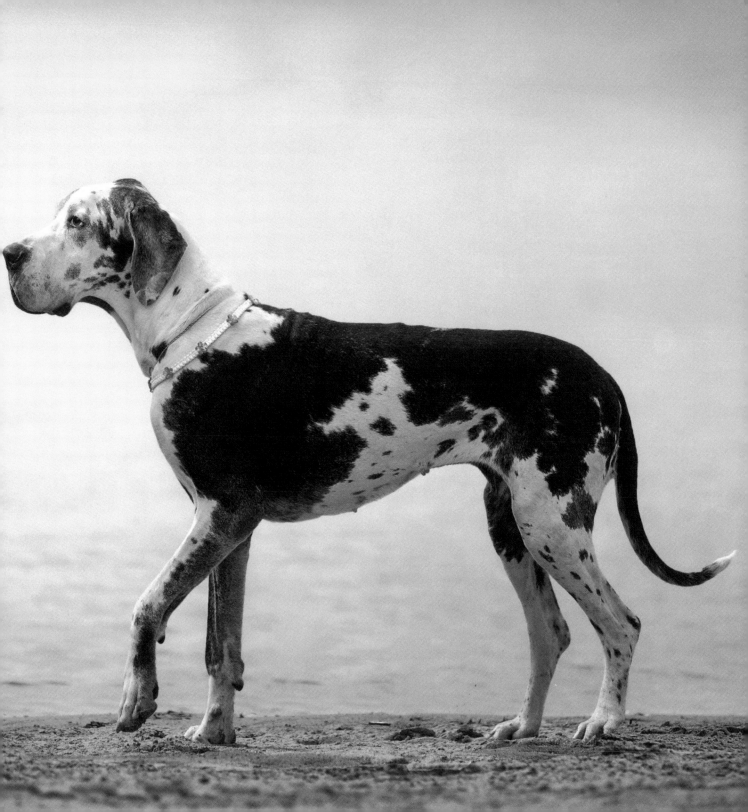

GOAL TENDED

Timothy can't wait to visit Grandma, because he loves her — and she always bakes delicious cakes for him. Not to mention she lives with six Bracci Italiani that Timothy never tires of playing with!

Timothy always helps his grandmother with chores, but one day she gives him his biggest job ever. "We're having a lot of guests tonight, and I don't have time to do anything," she says, throwing up her hands. "I need you to walk the dogs!"

Timothy has never walked all the dogs by himself before, but he nods confidently. After all, his grandmother always tells him what a big boy he is. Putting all six on leash, Timothy walks them in the park near the house, but it's very small and the walk is soon boring. They pass a yard where a few boys are playing soccer.

"Hey, Timothy, come join us," one shouts. "We don't have enough players!"

Sorely tempted, Timothy just shakes his head. "I can't — I'm walking the dogs."

"Maybe we can all play together," the older boy suggests.

It is probably the most fun game in the history of the sport — six Italian hunting dogs and six boys chasing a ball all afternoon. Almost immediately a crowd of onlookers gathers, laughing and commenting about successful shots and the dogs' deft interceptions.

It's a long time before Timothy gets home. Grandma is still fussing, running between the kitchen and dining room, and Timothy helps her. When the guests arrive, Timothy tells them all about the game, as the exhausted dogs snooze in a heap. After dinner, Timothy hugs the oldest Bracco on the couch and drifts off to sleep. Taking a minute from her hostessing duties, his grandmother kisses him on the forehead. "You are very clever, my lovely big boy!"

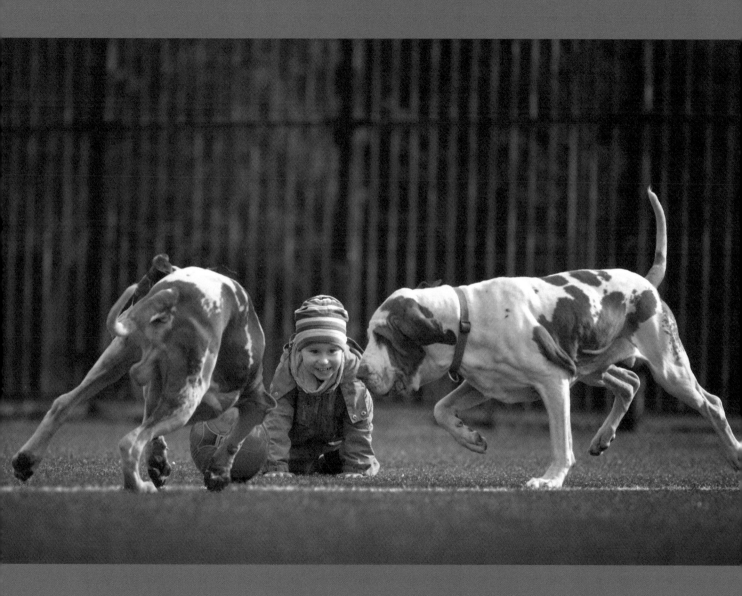

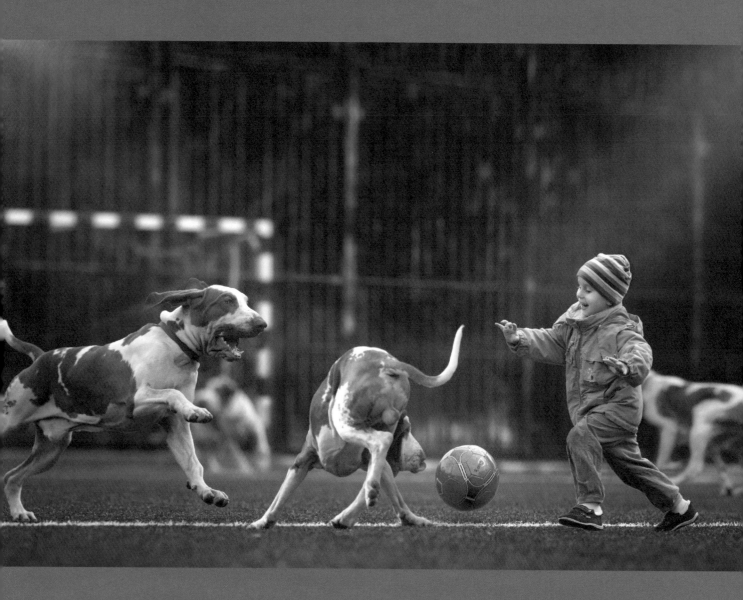

30

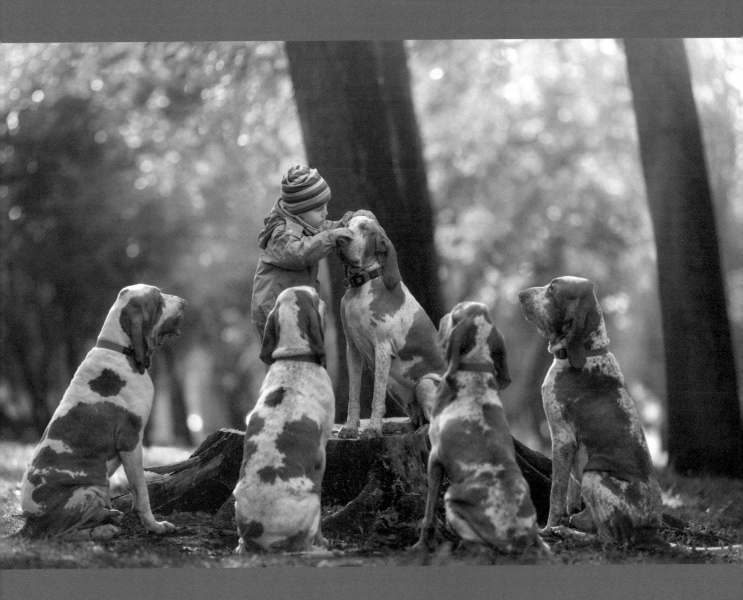

SOUNDS OF SILENCE

Little Matthew is talking to his big friend Misha the Saint Bernard. Except, of course, neither of them can talk — at least, not in the way most people define the word.

"If I could speak, I'd tell you how important it is to me that you came to the park today, how much I love to walk with you, and how calming your big, wet nose is," Matthew thinks. "With you I can play and have fun, or just be silent. Today the weather is perfect, and we're walking again in the park by the river. I'm happy! What about you?"

Misha turns his great shaggy head and looks at Matthew.

"If one day a miracle happens and I am able to speak," Misha thinks, "I would talk to you on and on, again and again ... about the sun, about the green grass that we love to run around on ... and I would tell my owner that I want to see you more often. Tonight when I get home and go to sleep in my big, comfortable armchair, I'll be sad ... But not now ... Now, I'm happy!"

"Very soon I'll learn to speak," Matthew continues in his head, "and I will tell everybody about our friendship. I'll explain that despite your enormous size and fearsome appearance, at heart you're a child like me who loves to play, have fun and be mischievous. And I'll tell you that I was unbelievably glad to have met you. I hope that throughout my life I have lots of friends that are as loyal as you. What a pity I can't talk to you right now, but it is not really important, because we understand each other without words."

Matthew stops and looks around. "Well, let's run!"

On this beautiful sunny day, little Matthew and Misha the huge St. Bernard run side by side. They are happy. And nothing else matters.

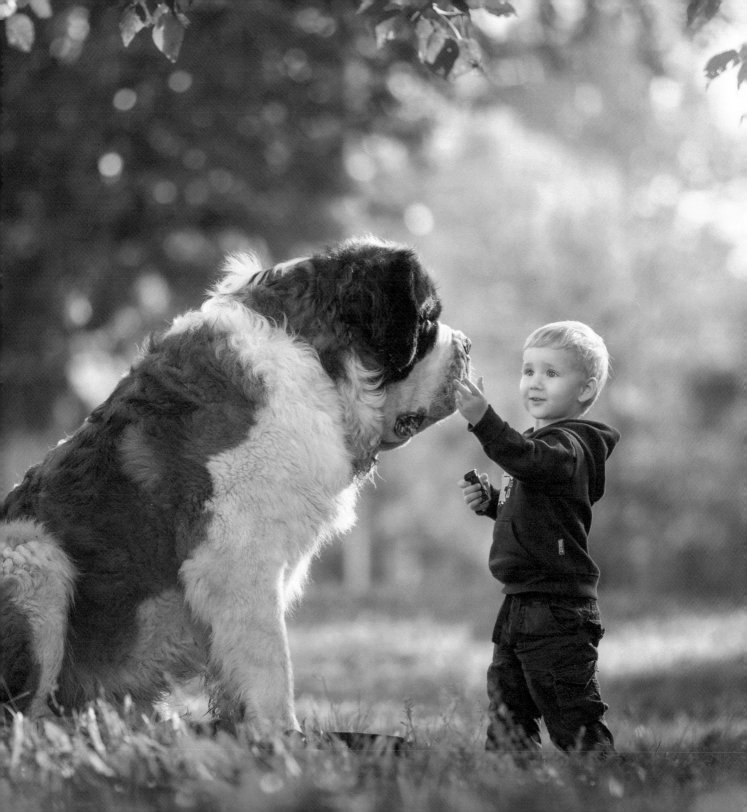

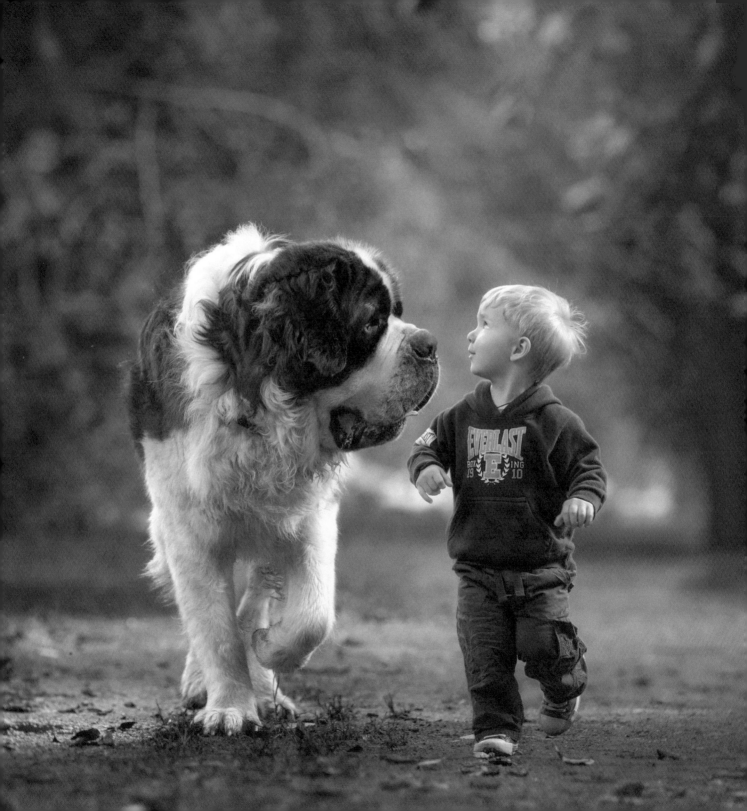

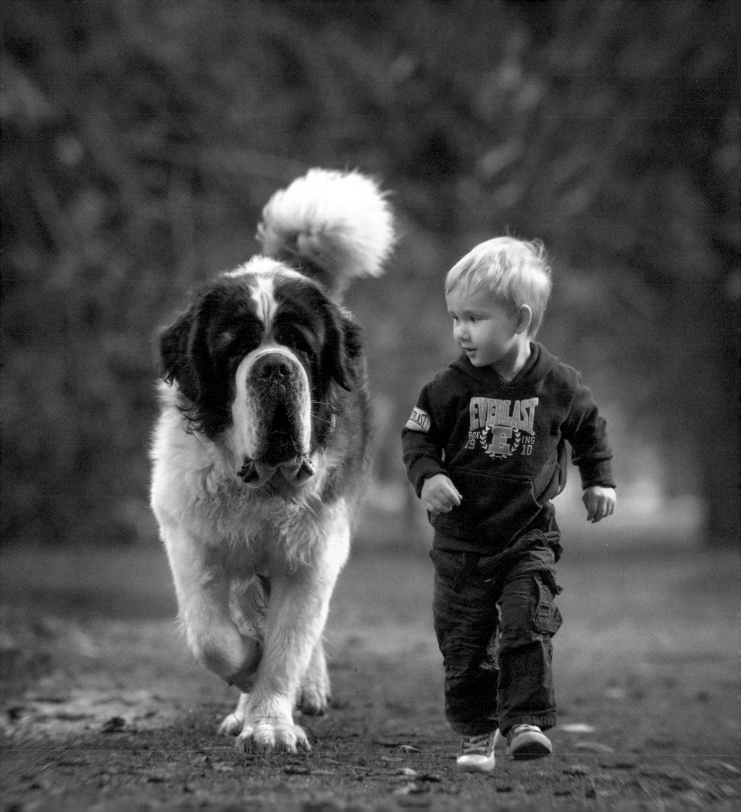

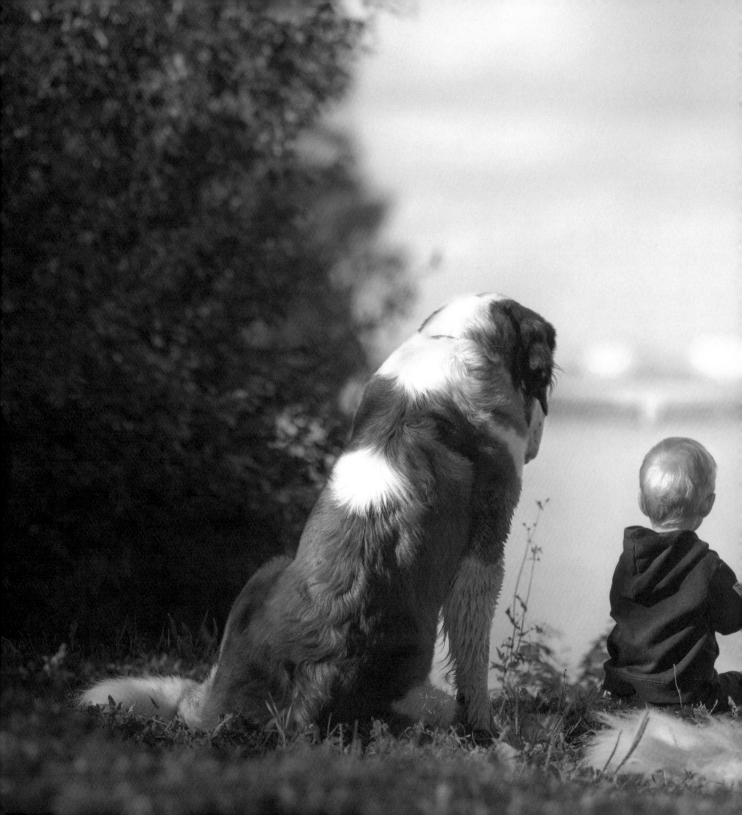

MOP TOPS IN THE SNOW

Little Arthur watches the snowflakes cover the ground like a soft white carpet.

"It's so much fun out there in the first snow. If I was out there, I would throw the snow up and then catch the snowflakes and watch them turn into water drops," Arthur thinks. All his friends are visiting their grandparents, so playing in the snow alone is no fun.

Suddenly he notices a wonderful creature that looks like the corded washcloth his mom bathes him with, but a *r-e-e-e-ally* big one. A wet black nose clings to the window.

"Who are you?" Arthur asks.

"I'm Zeus. I'm a Komondor. That's the name of my breed," the Hungarian herding dog responds. "I came out to play, but two are better than one. Let's play together!"

Arthur slips on his coat, flings a scarf over his shoulders, grabs his gloves and rushes outside.

Zeus welcomes Arthur by wagging his shaggy tail, and they run through the snow, jumping and catching snowflakes. And when Arthur's hands get cold after playing in the snow, the Komondor lets him warm them in his heavy corded coat.

It's an amazing walk. Saying goodbye to his new friend, Arthur gives Zeus a big hug and pats him on his wet black nose. "Come back tomorrow," he says. "We'll play another fun game."

Zeus licks Arthur's cheek. "Woof!" he replies. "I surely will, my little friend!"

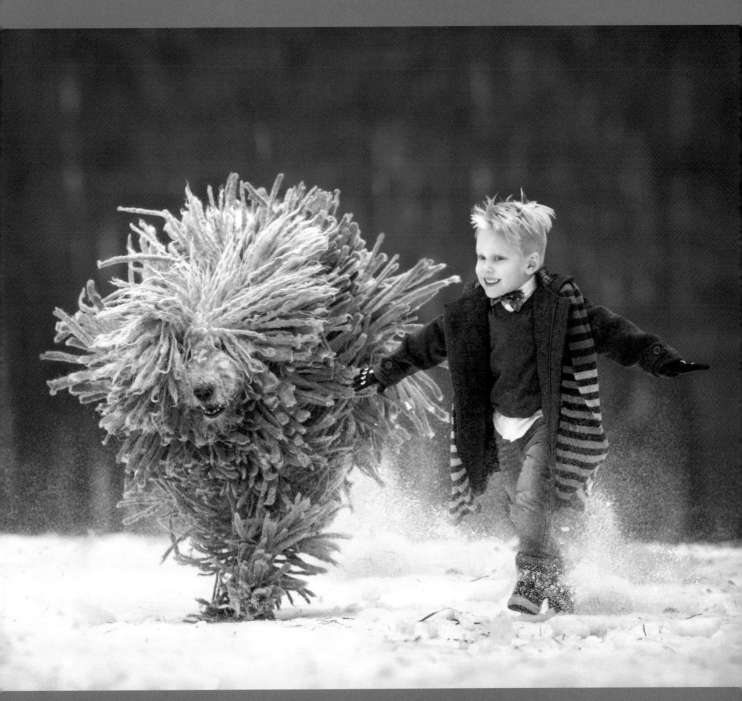

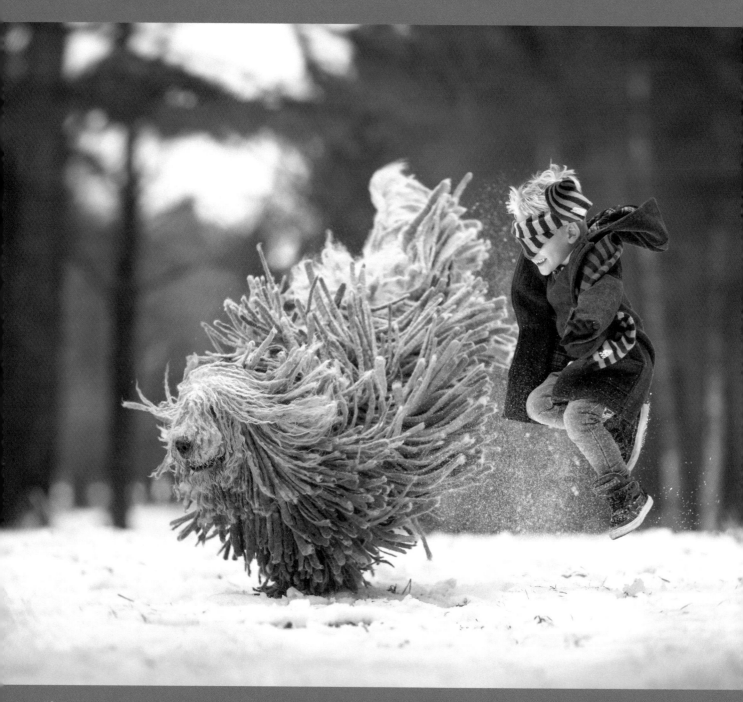

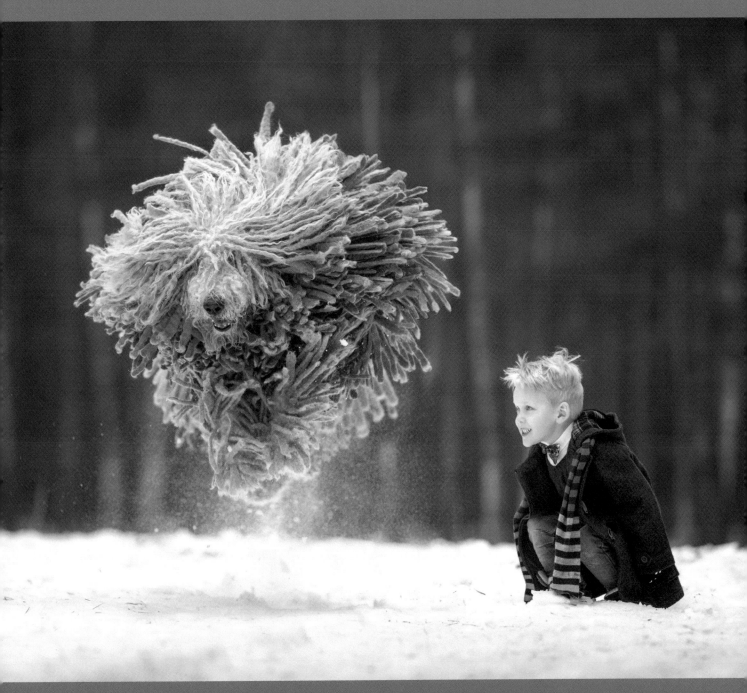

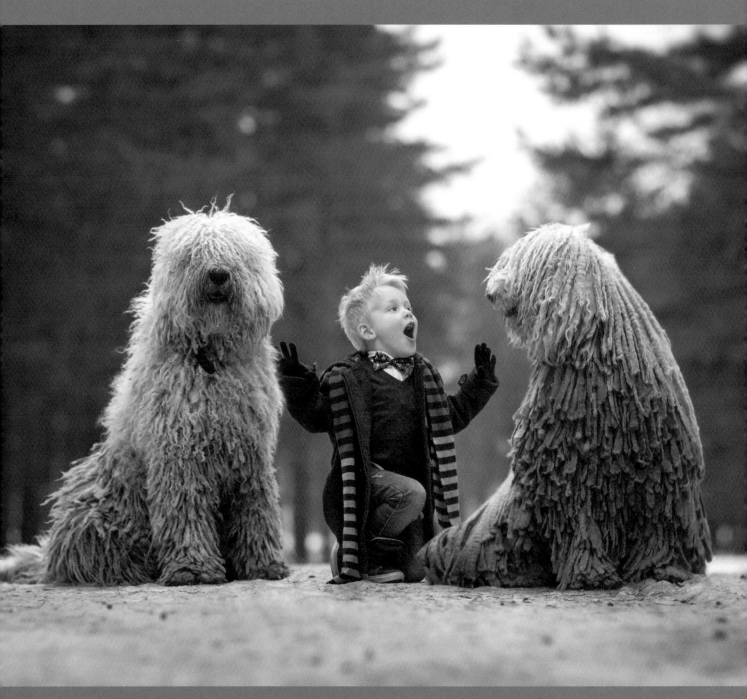

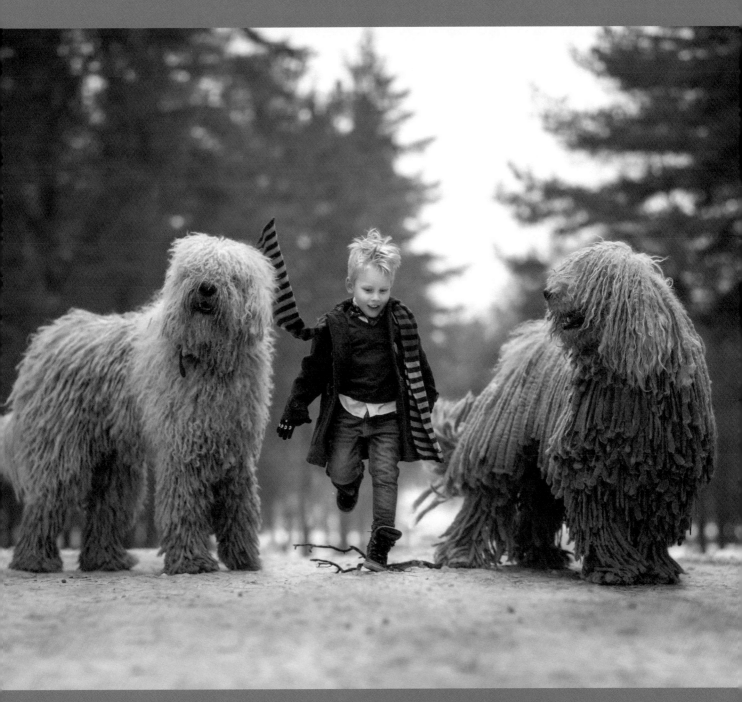

THE ETIQUETTE LESSON

On a warm and sunny autumn morning, Anya walks with her friend Tsypa the Dogue de Bordeaux. The huge maples drop yellow and orange leaves that swirl the air and cover the park's paths like a golden carpet. They are a perfect match to the amber eyes and red coat of this French Mastiff, famous for its "sour mug" expression.

But Tsypa isn't a cranky dog at all. She gently pushes Anya away from the edge of the path. Then the two run side by side, enjoying the last warm rays of the sun that are heating Anya's cheeks and Tsypa's back.

"Tsypa, you're so wonderful!" Anya says when they stop to have a rest. "But you need better manners. When you yawn, you should cover your mouth with your paw! That's what my mom says."

"Your mom is right," Tsypa nods in agreement.

Slowly they walk back to where Anya's mom is waiting for them. Anya has so much more to teach Tsypa about good manners: how to greet people, and to say "please" and "thank you." Tsypa listens attentively and guides Anya onto the right path. Sometimes when the girl stumbles, the solid Dogue catches and steadies her.

"Tsypa, I love you so much," Anya says as she hugs the big dog goodbye. "But we still have to work on your manners. So you should definitely come again tomorrow!"

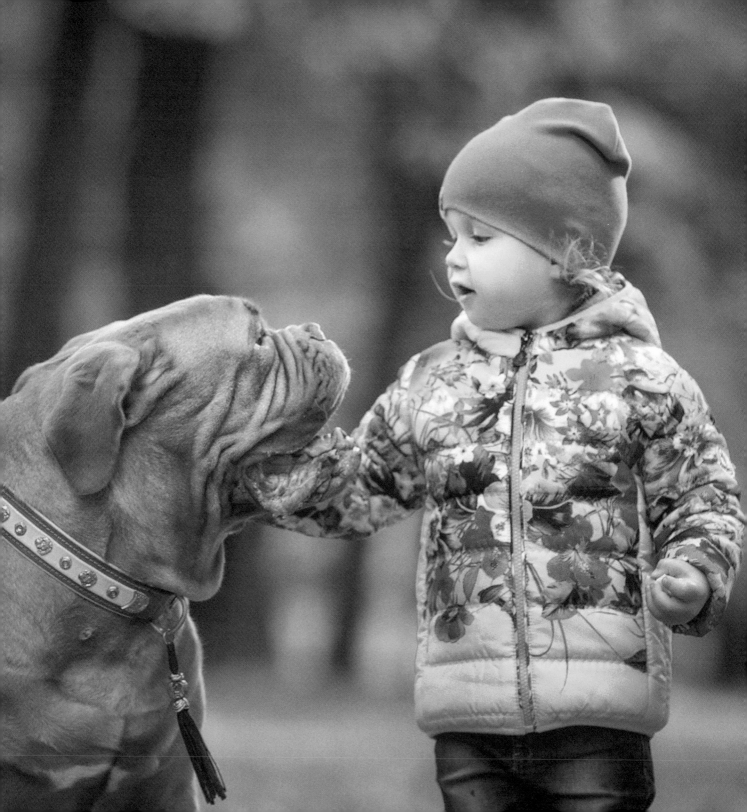

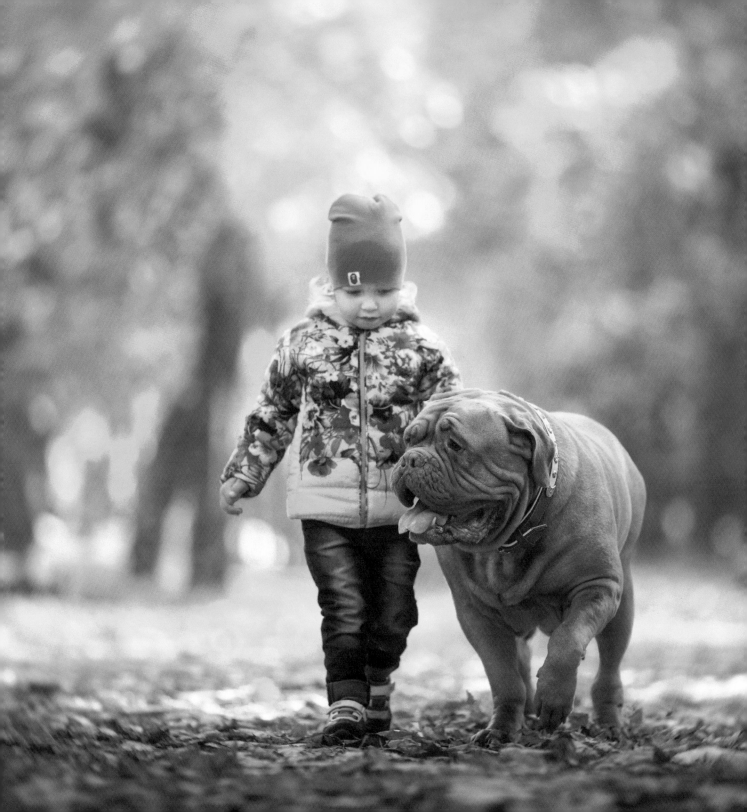

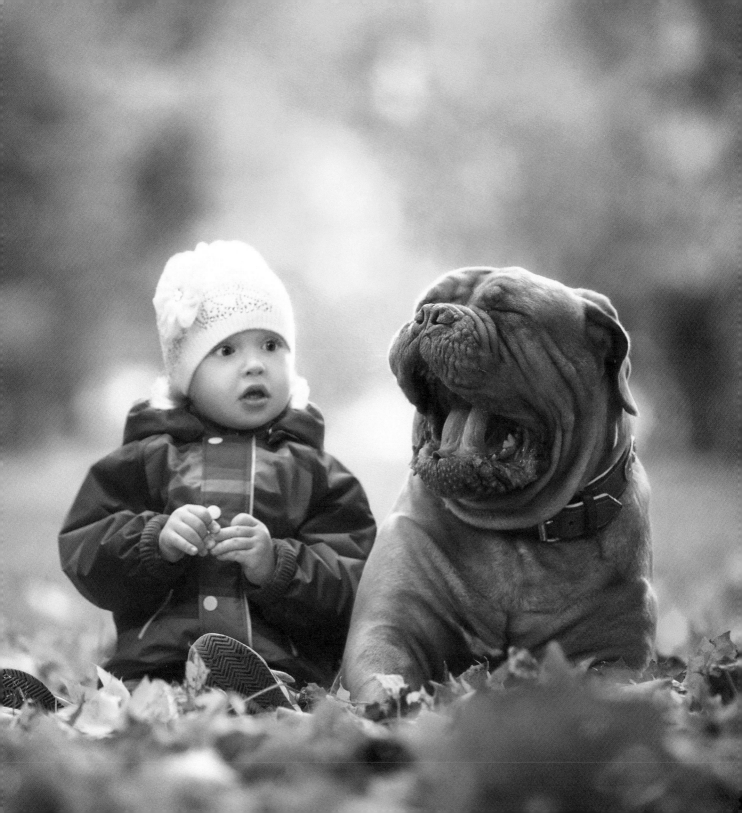

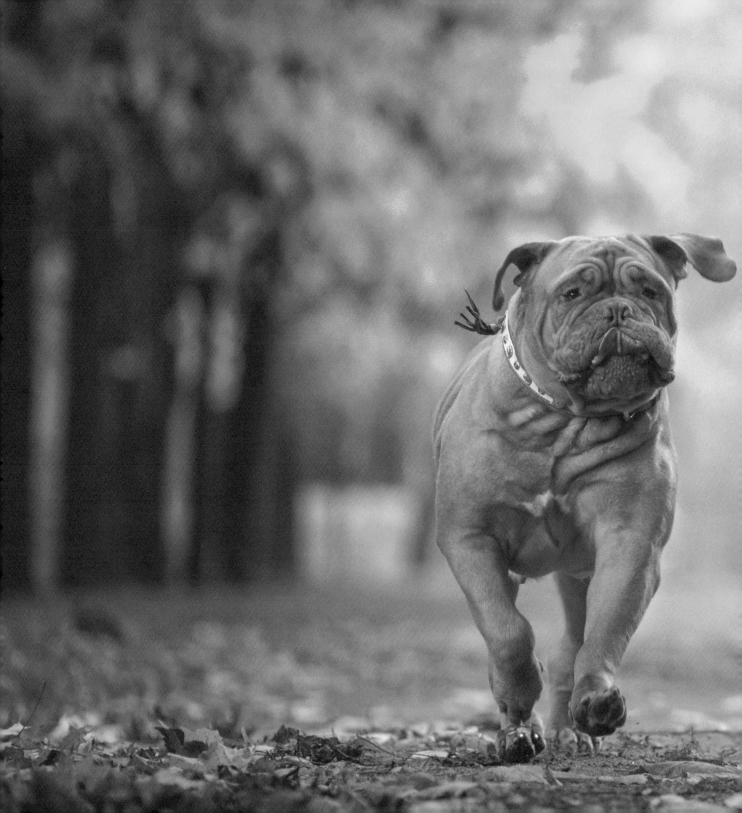

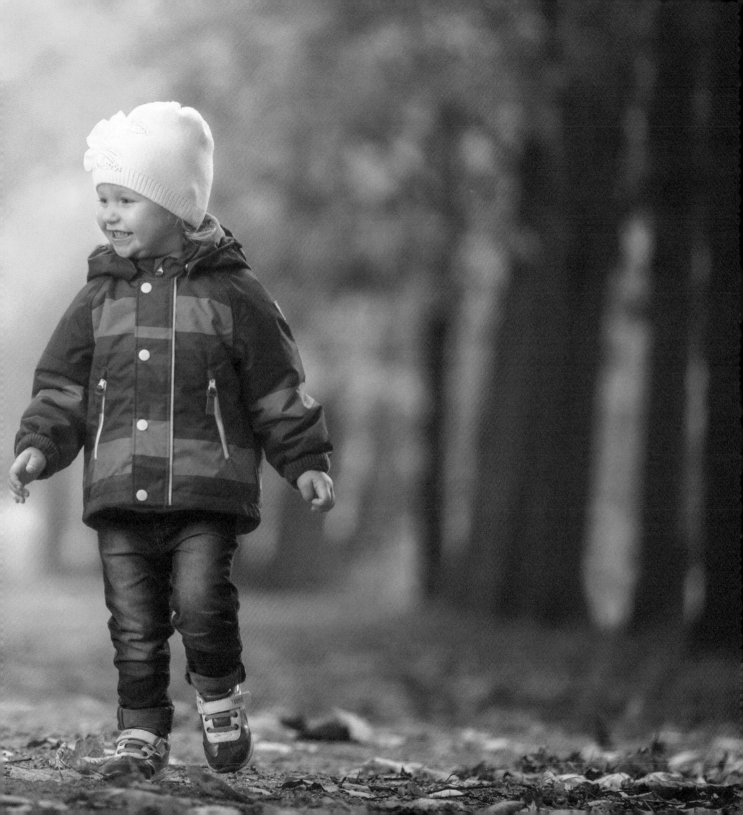

LOVE IN BLACK AND WHITE

Anna lives in the center of Saint Petersburg. She loves bicycle riding and swimming, and has a lot of friends and a wonderful cat. But, sadly, she hasn't got a dog.

One day, while Anna and her parents are walking in the park, they meet her mom's co-worker, Julia, who owns a Great Dane named Leonella. The dog's black-and-white coat pattern has a special name: It's called Harlequin, after the Italian slapstick character in the *commedia dell'arte*. And Leonella is quite a jokester, too.

Mom and Dad have never seen such a big dog before, but Anna isn't scared at all. She's very happy to meet Leonella. While the adults talk, Anna sees that Leonella loves to run, jump and play in the fallen leaves — just like Anna does. By the end of the walk, they are fast friends.

That evening at bedtime, Anna asks her mom to call Julia.

"Why would you want me to call her?" Mom protests. "She's probably asleep already."

"I want to talk to Leonella," Anna says.

Back at school, Anna tells her friends in her kindergarten class that Leonella is the best, kindest and most cheerful dog in the world.

"Do you know, she is no ordinary dog — she is a champion of Russia, the Republic of Belarus, Estonia, Latvia and Italy," Anna says proudly. "This year Leonella became a world champion!"

But even more important, now Leonella is the champion of Anna's heart.

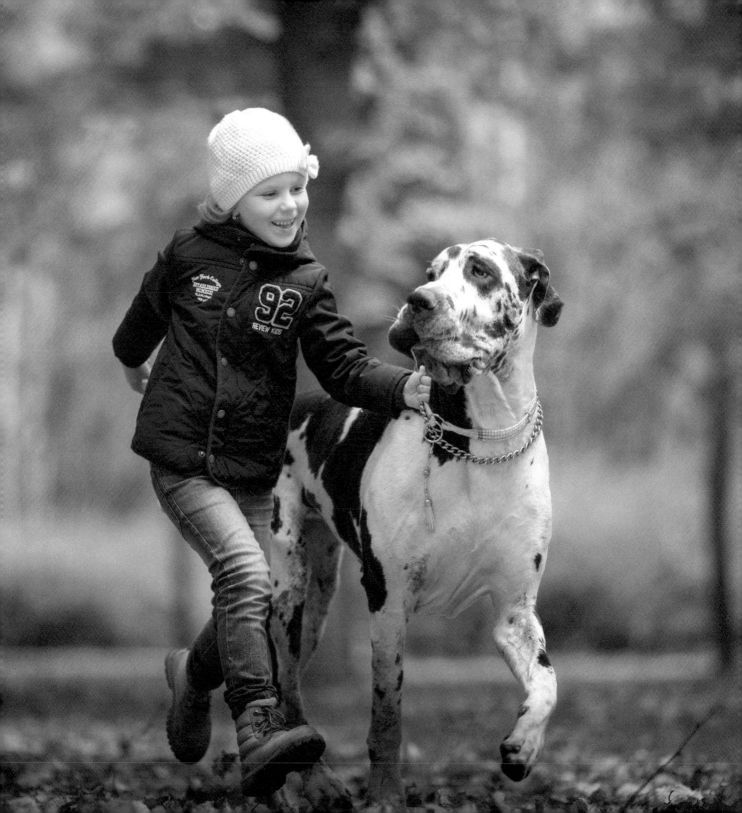

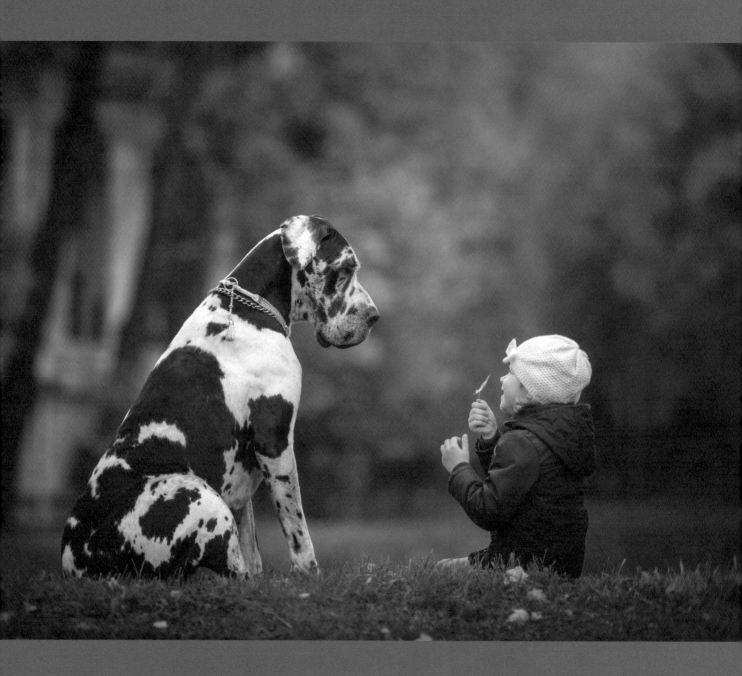

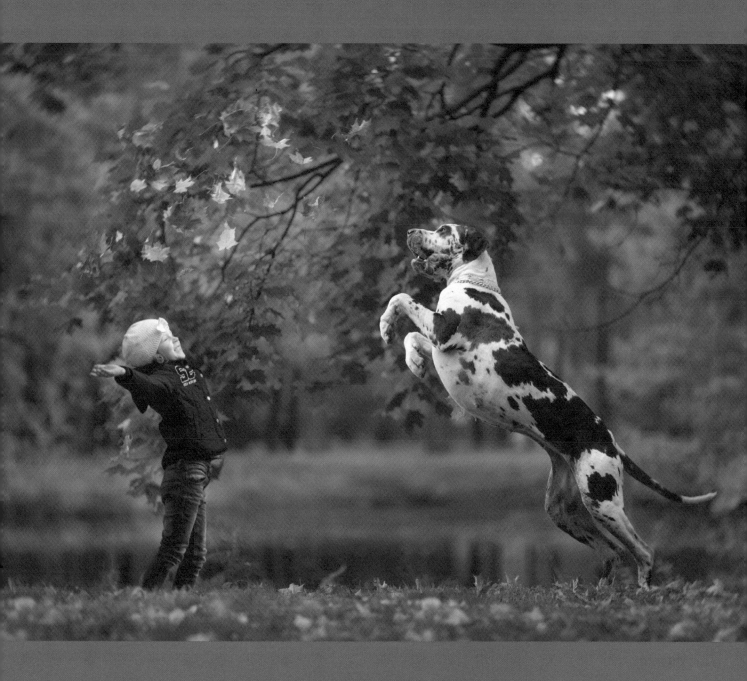

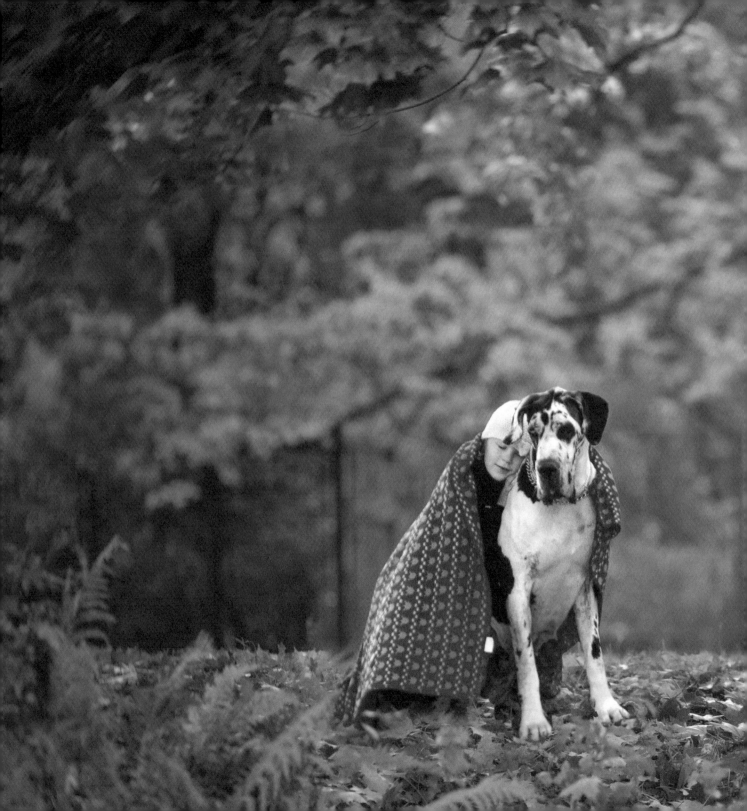

MODERN MYTHOLOGY

One day on a walk, little Lisa tells her Leonberger friends about a story her mother read to her from a book with beautiful pictures. In it, a dragon kidnapped a beautiful princess, and a brave knight came to save her.

"You know," the girl tells them, "I want to be a princess when I grow up!"

"You are a princess now," replies one of the Leonbergers. "Just a small one!"

"Well, no," Lisa sighs. "All princesses have knights, and I don't, so I'm just a little girl!"

"I'll be your knight!" volunteers Prosha. Lisa walks a few steps and contemplates the German dog. A huge, fluffy Leonberger isn't exactly a knight in shining armor. But, the girl reasons, Prosha always walks near her. He's the first resort if little Lisa suddenly stumbles.

"Yes, please!" she responds, turning to Vasya and Misha. "And you can be his squires!"

"And I'll be your lady in waiting," Varya, the only girl in the group, pipes up.

Prosha shakes his mane and it shines even brighter in the rays of the autumn sun. "Now we need to find a dragon!" Prosha says, arching his neck in front of Lisa so she can grab his collar.

"Forward! On to adventure!" he cries.

And so Princess Lisa and her magical retinue rush into the fabulous autumn forest.

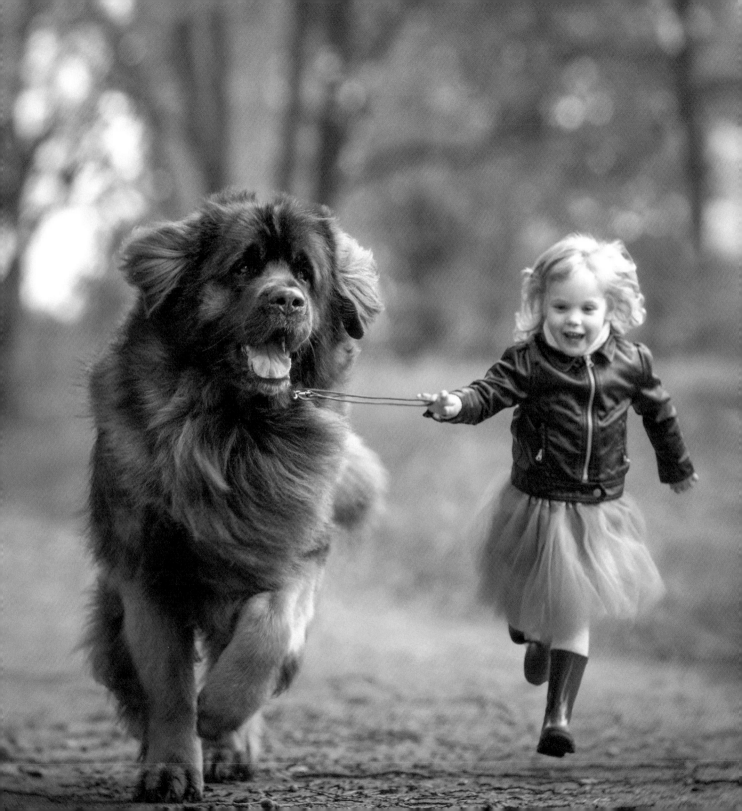

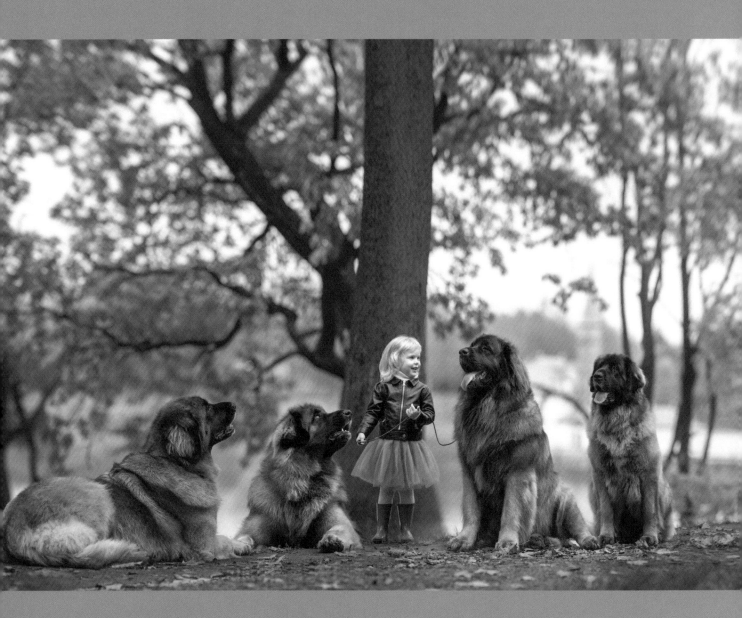

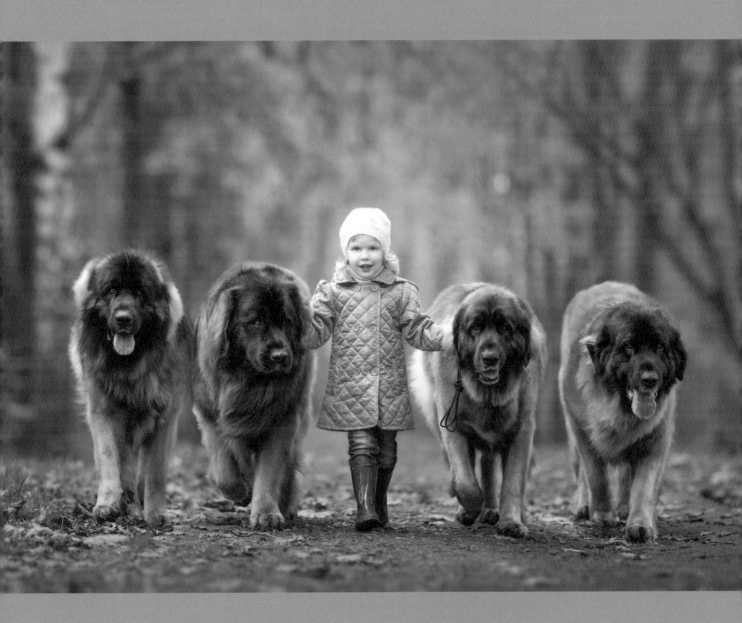

THE SPIRIT OF THE FOREST

Marusya isn't allowed to go to the far end of the garden. Her older brother says an ancient spirit of the forest lives there, in the deep shadow of the fir trees.

One day, as Marusya plays with her kite, the wind takes it straight to the place where she can't go. Marusya is scared, but she likes her kite very much, so she decides to wear a mantle of invisibility so the spirit of the forest won't see her.

Marusya put on her grandmother's old shawl and steps very carefully through the brambles. The overgrown path goes downhill to the banks of a frozen pond. Marusya sees the kite in the branches of a birch tree and runs toward it. But something big and black steps in her way.

"Stop! You can't step on the ice — it's too thin," the black specter announces.

"Are you the spirit of the forest?" Marusya asks.

"No, I'm an Afghan Hound. I live nearby and love this quiet corner of the garden. I will show you how to get around the pond."

"You must be a very ancient Afghan," Marusya says respectfully, glancing at the long white strands in the dog's black beard. Weiss the Afghan smiles. "I'm not, but my kind is."

As soon as they reach the birch, a gust of wind catches the kite and carries it again into the sky.

"Don't cry, Marusya," Weiss comforts her. "Let me show you some very old Afghan Hound magic." And with that Weiss leaps into the air, his gorgeous black coat spreading out like raven's wings.

Later, when Marusya shares her adventure with her brother, he doesn't believe her. But it's true. She really did meet the ancient spirit of the forest.

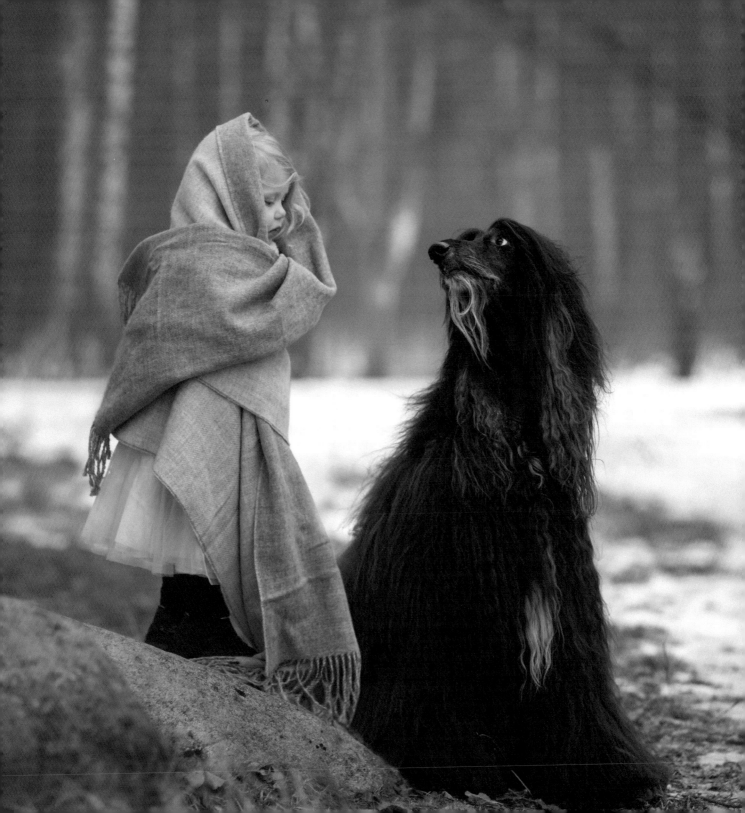

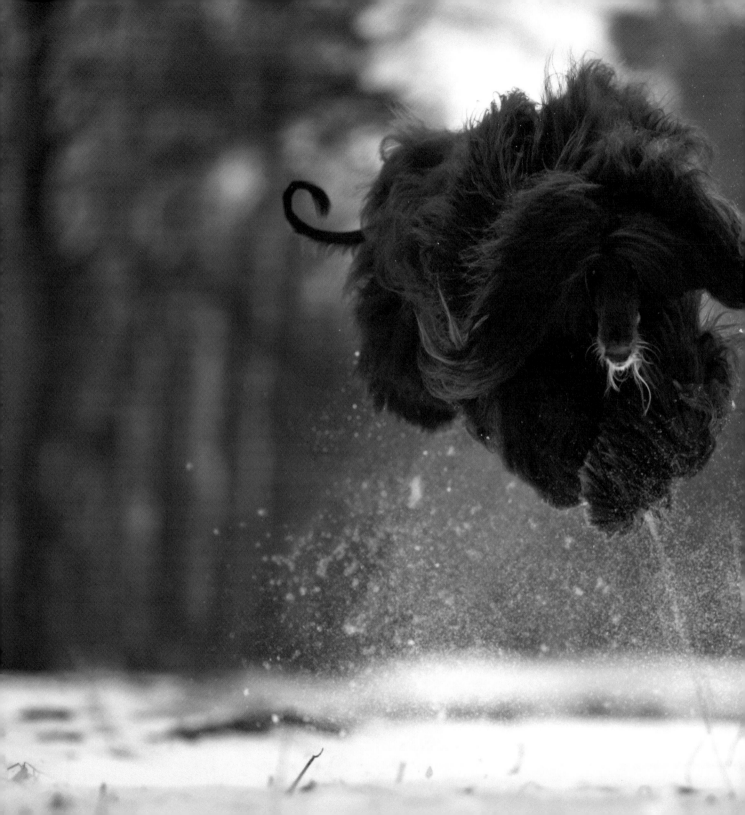

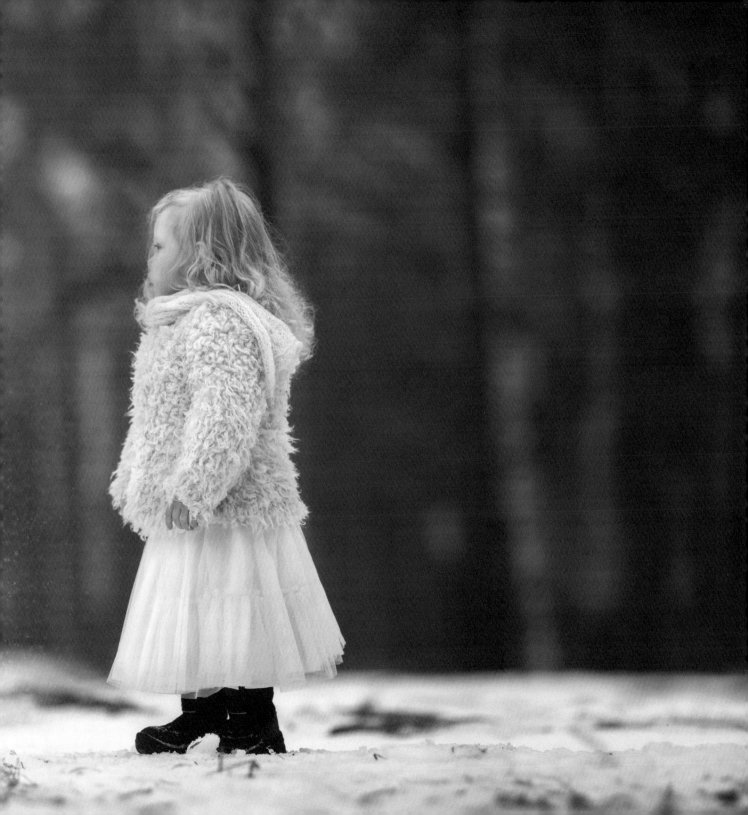

THE ART OF WISHING

"What a pity, my furry friend Misha went to a dog show," thinks Matthew as he walks in a park that's wrapped in a blanket of bronzed leaves. "I really wish he was here to run through these leaves with me!"

Suddenly, the two large dogs who look very similar to Misha appear out of nowhere. They are Saint Bernards, too, but with short fur. At first Matthew is a tiny bit scared, but the friendly dogs wag their tails.

"Their name are Chick and Bruno," says the man who appears behind the furry duo. "They are smooth-coated St. Bernards."

"St. Bernards are magic dogs," Matthew thinks to himself. "They appeared just as I was thinking of Misha."

"Do you want to play with them?" the man asks. Matthew's eyes light up. Of course, he wants — he *really* wants — to play with the dogs! They play tag and roll in the leaves, and then twilight starts nibbling around the edges of the day.

"It would be so great to meet Chick and Bruno again," Matthew thinks.

"All you need to make it happen is a strong wish," Bruno whispers.

"You can read my mind?" says a surprised Matthew.

"Well, you're the one who said we are magical dogs!" Bruno winks.

Darkness starts to fall, and the park empties, but Matthew's heart is filling with light. What a wonderful day of magic. Open your heart to the world, and a miracle will always be there!

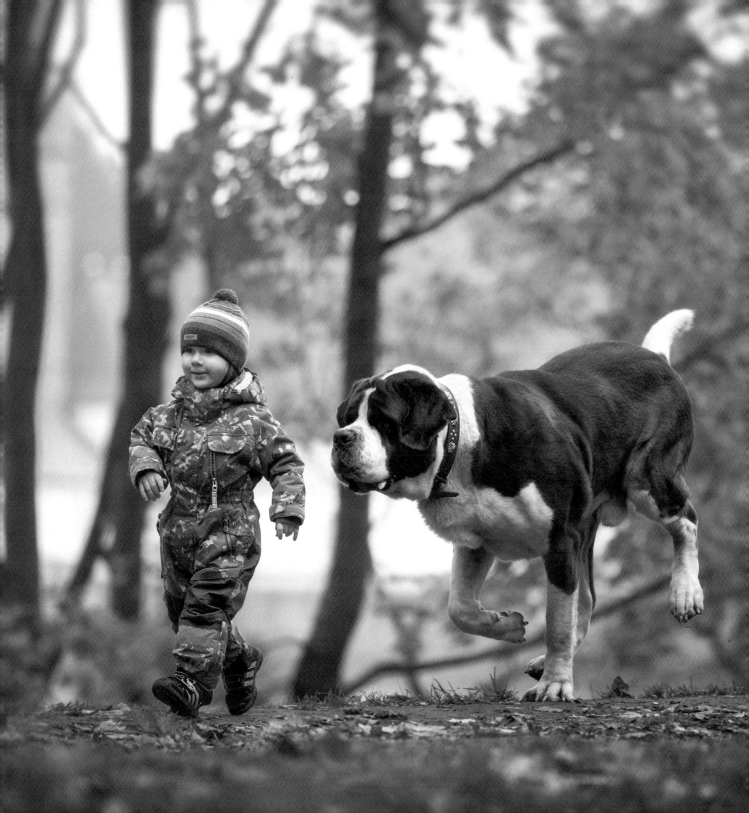

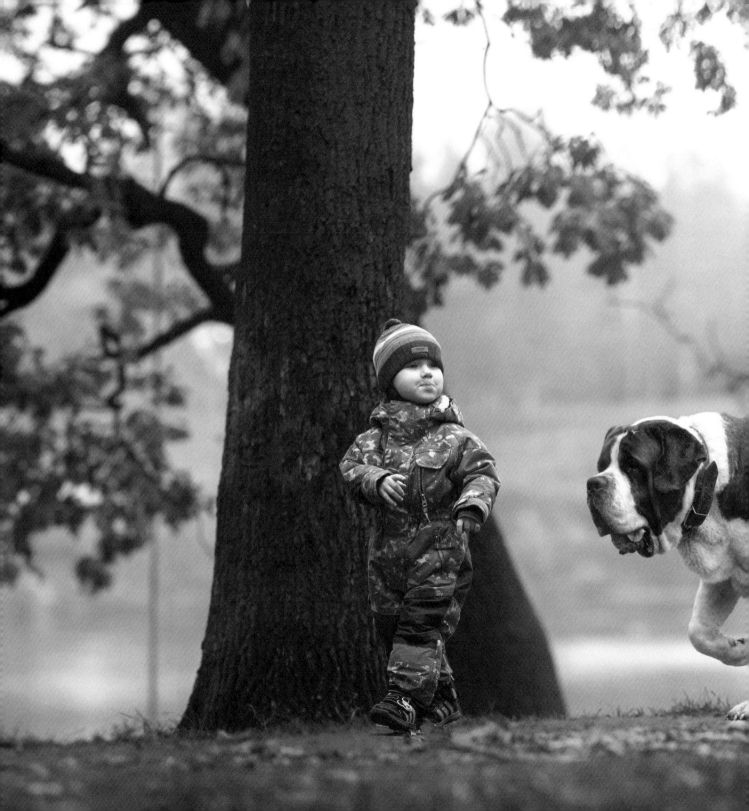

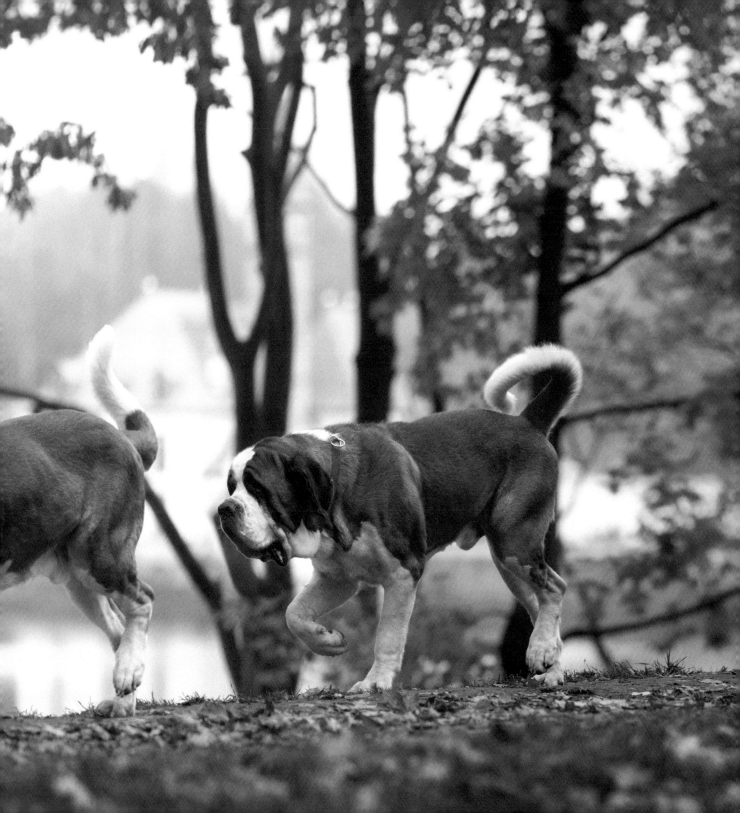

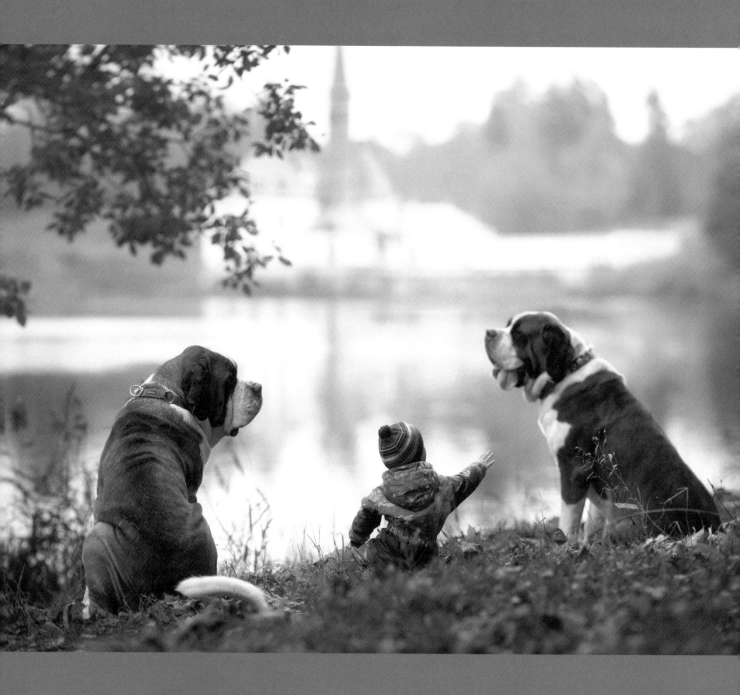

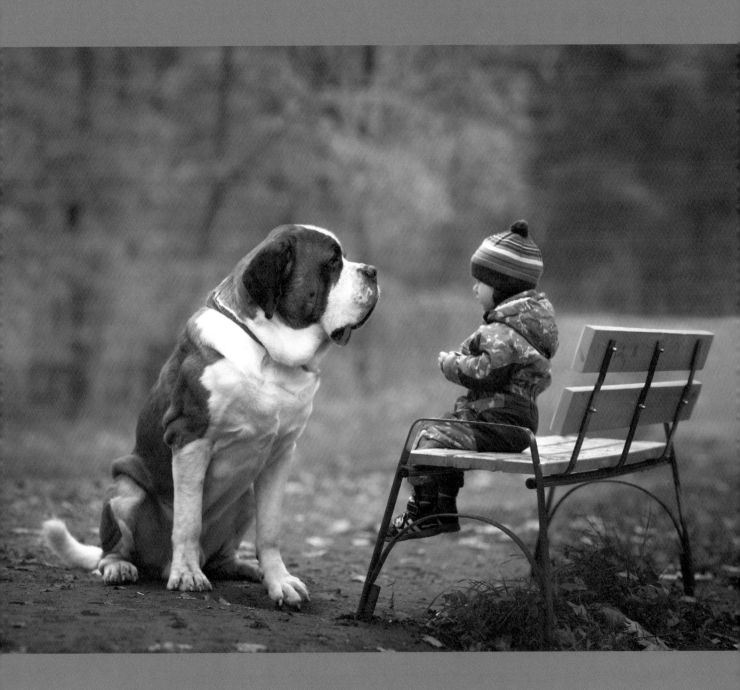

JOB SECURITY

"Tell me, Morgan, do you think our Max will become a veterinarian when he grows up?"

Two Irish Wolfhounds named Keegan and Morgan walk side by side with their owner Max. At six years old, Morgan is already a senior, and Keegan is barely a yearling puppy.

"Well, I don't know," Morgan answers. "It seems unlikely to me. He likes cars and music."

Young Keegan squints slyly. "You know we are going to meet Sonya now. Her mother is our veterinarian," he says. "Sonya is always there when she gives us our vaccinations. And Sonya wants to become a veterinarian! Do you understand now?"

Morgan shakes his head: "Frankly, no."

The smaller Wolfhound runs back up the path and back. "Max and Sonya are friends for a long time, and he certainly likes her. She wants to be a veterinarian, and Max wants her attention, so ..."

Sonya appears in the distance, and Keegan runs from her to Max and back again. Sonya tousles the fur on his head and behind his ears. Keegan comes up to get his portion of petting.

"You see," Keegan says insistently, "how Max likes Sonya!"

Morgan laughs. "Silly, that doesn't mean that Max will become a vet!" But the young Wolfhound is distracted by a stick. Soon enough he bounces back, returning to his theory of love and vocation.

"Okay, Max will become a veterinarian!" Morgan announces in exasperation. This makes Keegan so happy that all the way home he congratulates himself: "Yes, Morgan is older, but I'm wiser!"

Morgan chuckles into his beard: Keegan is happy. If he's right, too, so much the better!

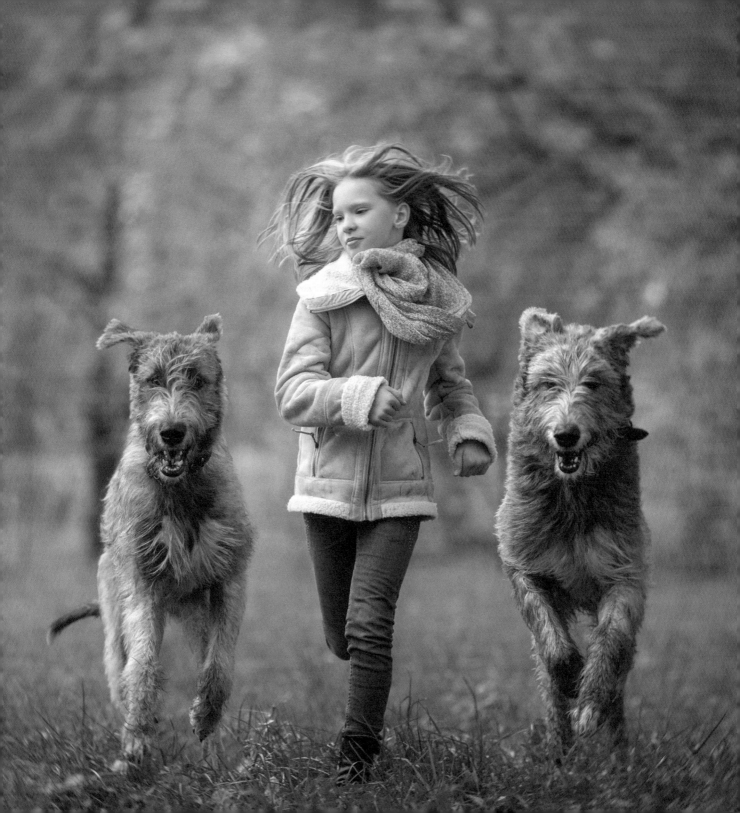

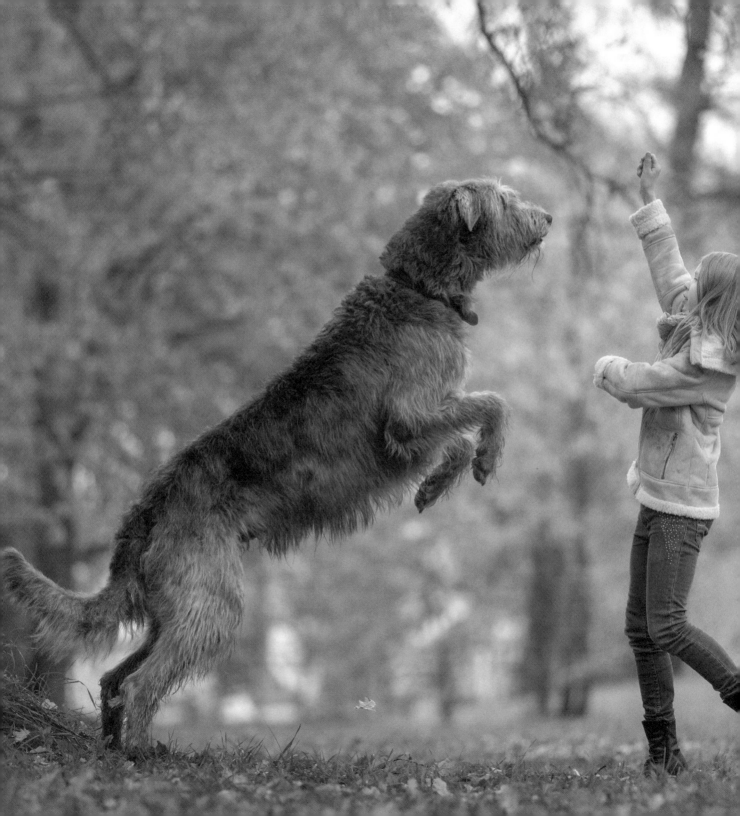

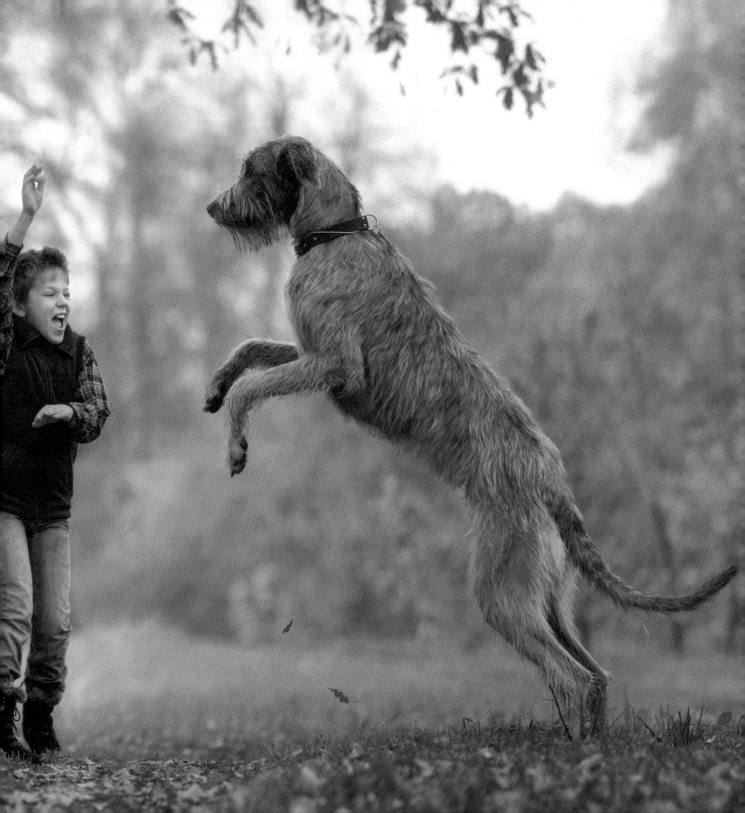

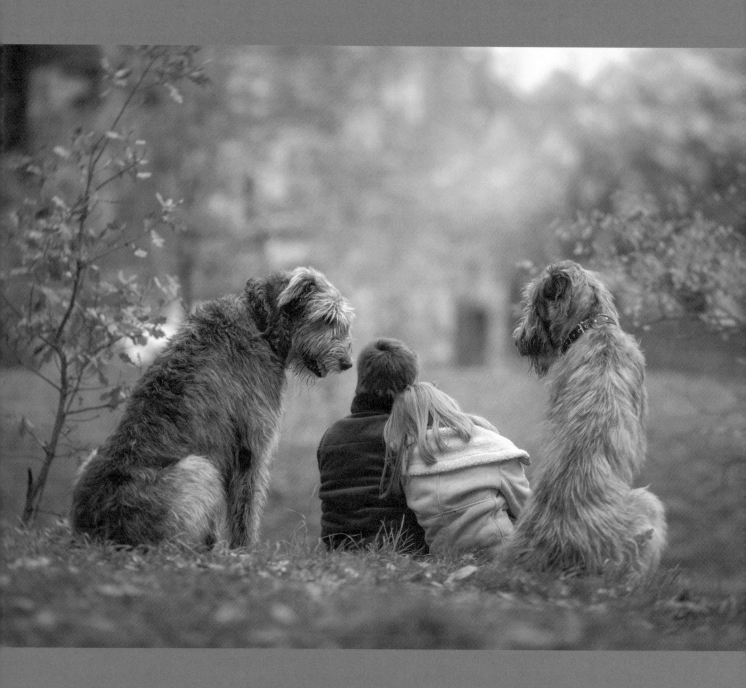

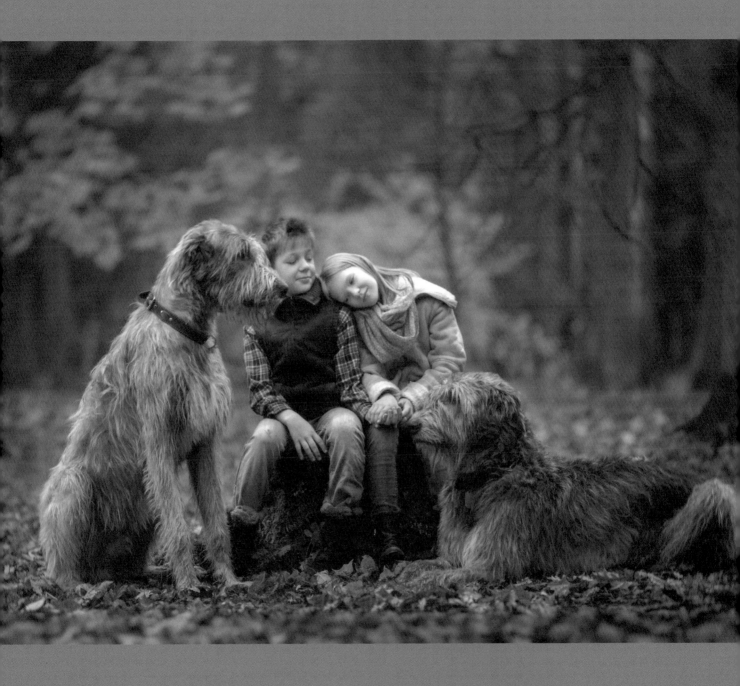

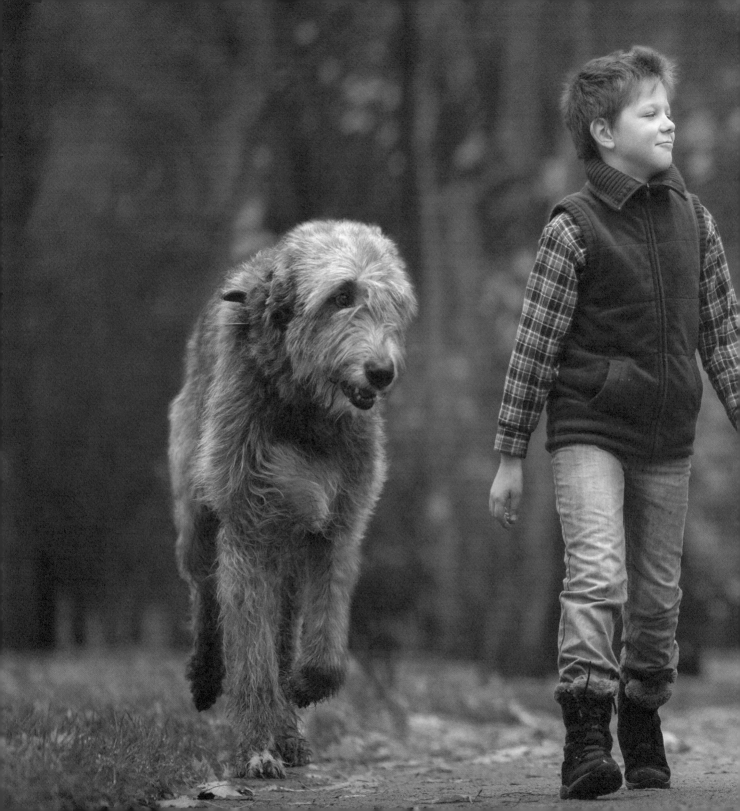

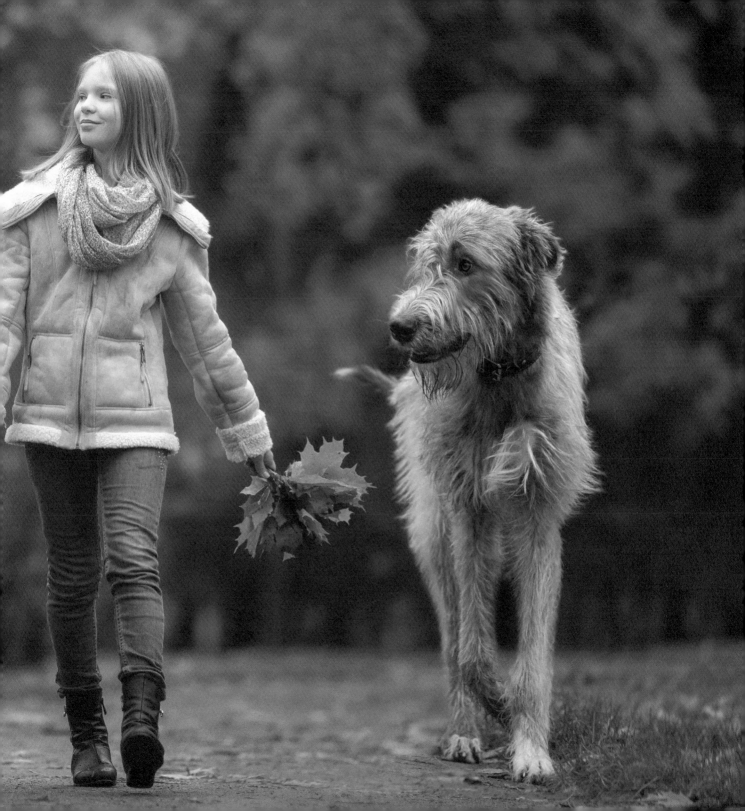

SONG OF MYSELF

This autumn morning is cloudy and cold, and Mon Amour the Great Dane is looking out the window, bored. Everyone in the family is going to work. Even the cats have disappeared somewhere.

Uuuuuuuu. Mon Amour lets her displeasure be known.

"Mon Amour, we'll be back soon," Irina says, zipping up her jacket.

"I have a photo shoot with Ringo the Newfoundland," Andy says, flinging a backpack over his shoulder. "It won't take long."

Uuuuuuuu, Mon Amour howls again. "You're going out with Ringo, and I'll be home all alone!"

Irina can barely hear her own voice above the din. "Well," she says, putting Mon Amour's collar on her, "it looks like we'll have to take you."

At the park, Ringo arrives with two children: Mon Amour has known Theodore for a long time, but she never met Alice. The girl completely charms Mon Amour, petting and admiring her. When Ringo gets tired of running from Mon Amour, Theodore is happy to continue playing with the stripey Great Dane. They run together for a long time — Theodore and Alice, and Mon Amour with Ringo.

On the drive home, Mon Amour starts singing about her wonderful day. *Uuuuuuuu.* Andy and Irina try to calm her, but happiness has flooded Mon Amour completely, and her song only gets louder.

Uuuuuuuu.

Trapped in the car, Andy and Irina have no choice but to join their Great Dane's fiery song.

Uuuuuuuu.

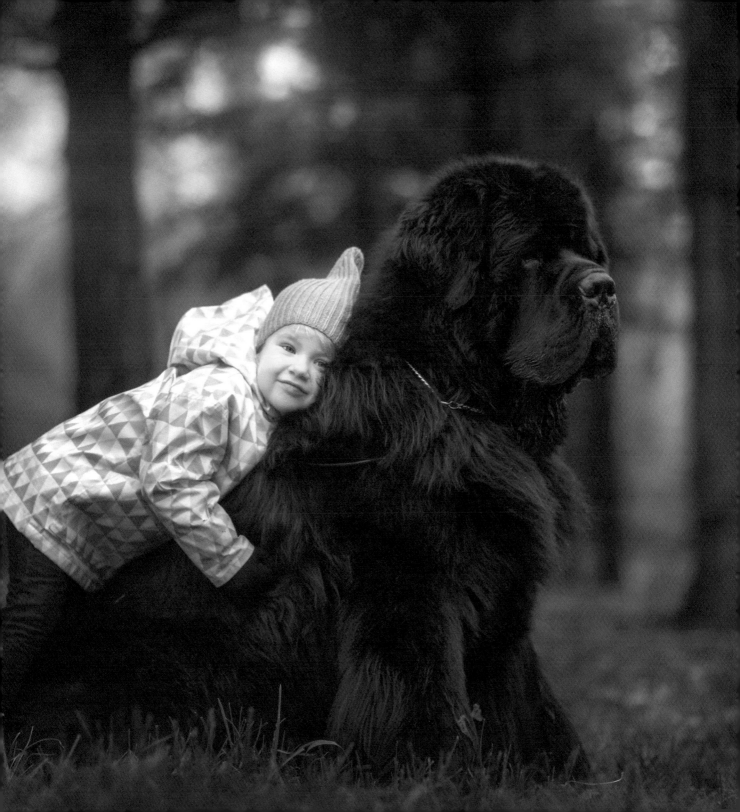

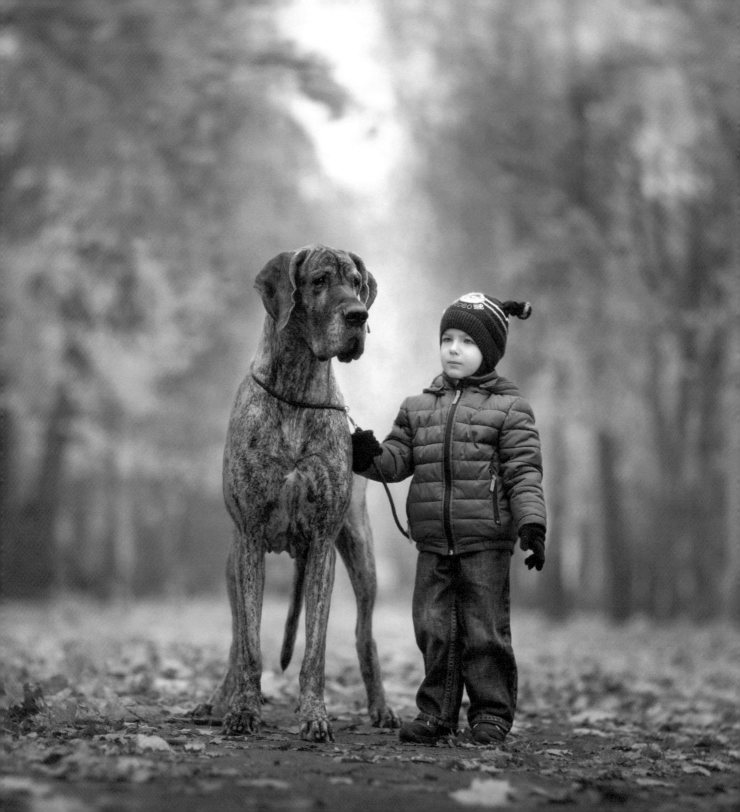

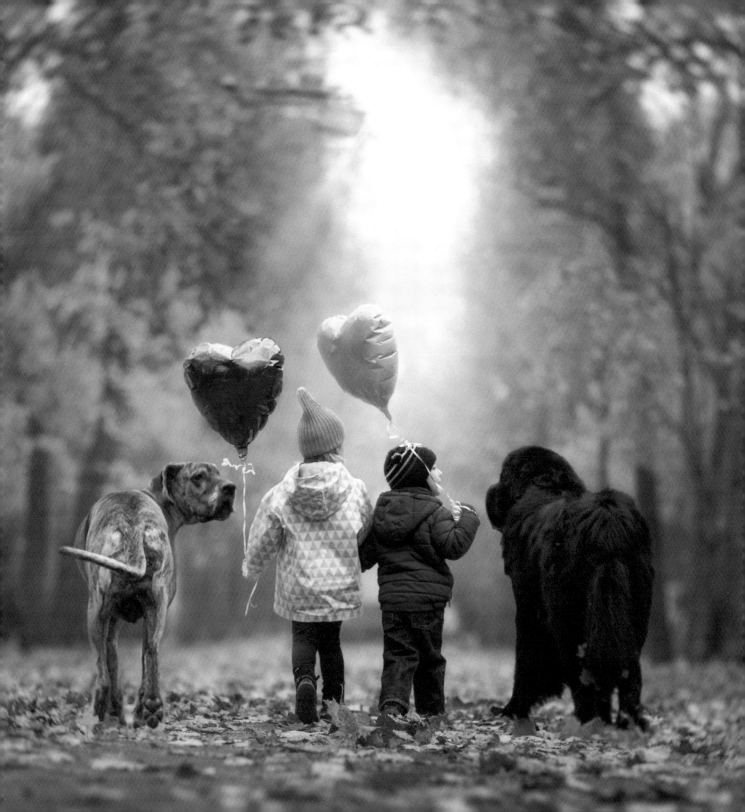

NO SUCH THING AS STRANGERS

Little Barbara and her friend Vasilisa, who is five, have never met a Black Russian Terrier before.

"Is it bigger than my grandmother's Moscow Watchdog?" Barbara asks as they walk briskly down the path to the photo shoot.

"I don't know," Vasilisa shrugs. She is busy trying to remember what her mom told her about how to greet a new dog: speak quietly and move slowly, because dogs need time to get to know you.

Hobbit and Kadrille trot along the path coming from the opposite direction.

"Have you ever met a little human?" two-year-old Kadrille asks.

"No," replies Hobbit, who is six, and seen much more of the world. "I hope they don't tug my ears."

The children and the dogs reach the clearing for the photo shoot at the same time.

"What funny fuzzy dogs," the girls think to themselves.

"What funny miniature people," the dogs think to themselves.

With adult supervision, the little girls meet the big dogs, and within minutes they are the fastest of friends. They chase each other around, raising clouds of powder snow. The girls' delighted laughter echoes in the silence of the frosty morning.

"Is Hobbit bigger than your grandmother's dog?" Vasilisa asks Barbara as they trudge off through the snow after bidding goodbye to their newfound friends.

"I'm not sure," Barbara scratches her nose thoughtfully. "But they're definitely more fluffy."

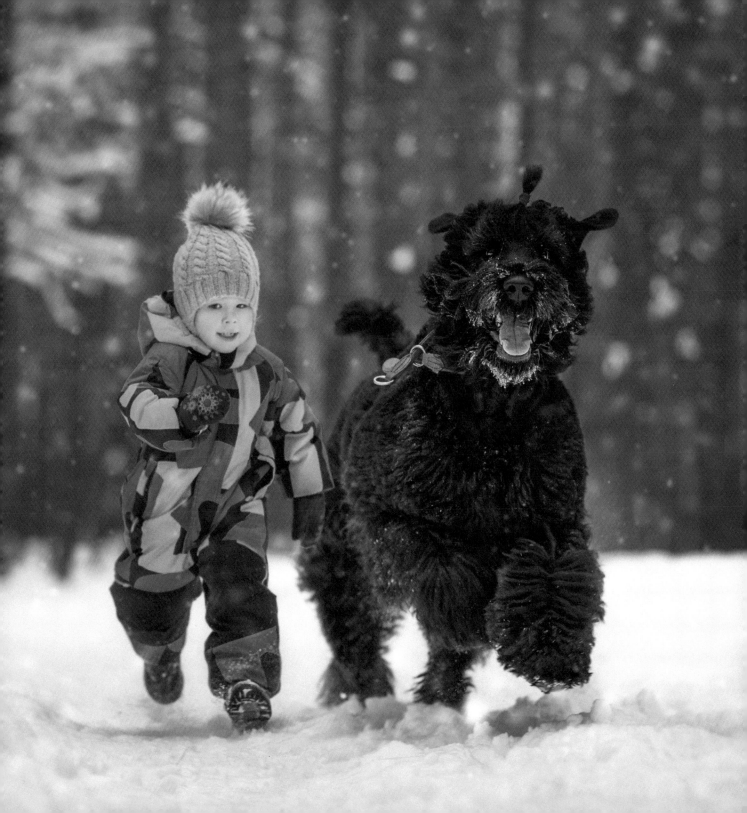

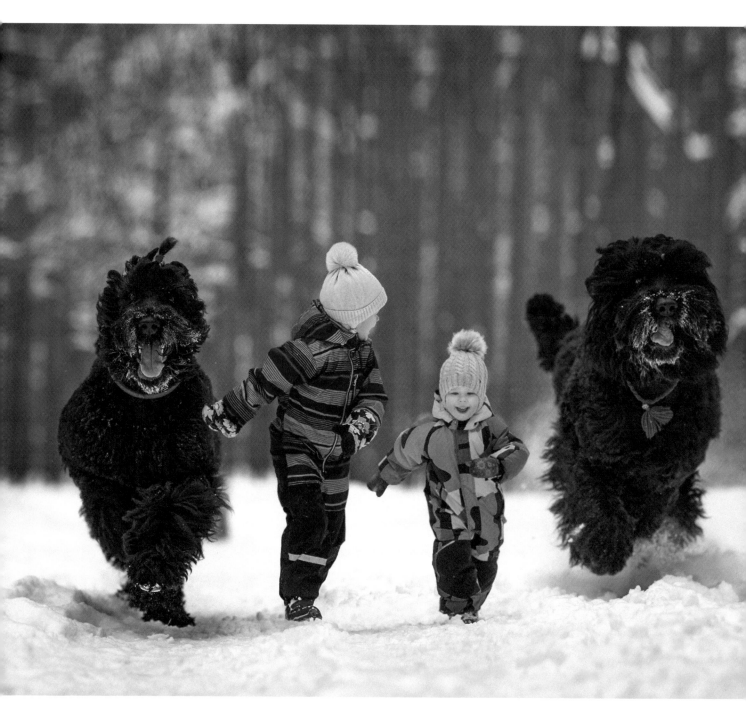

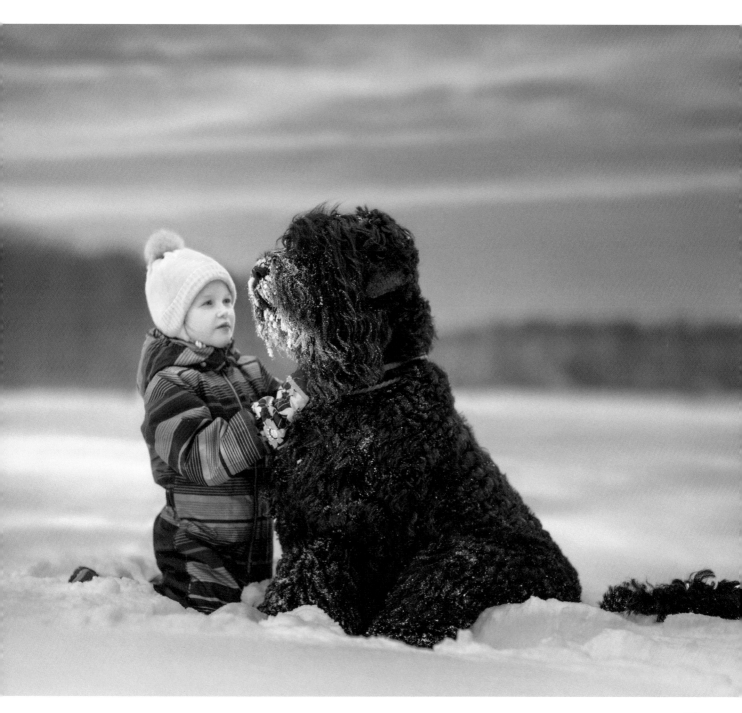

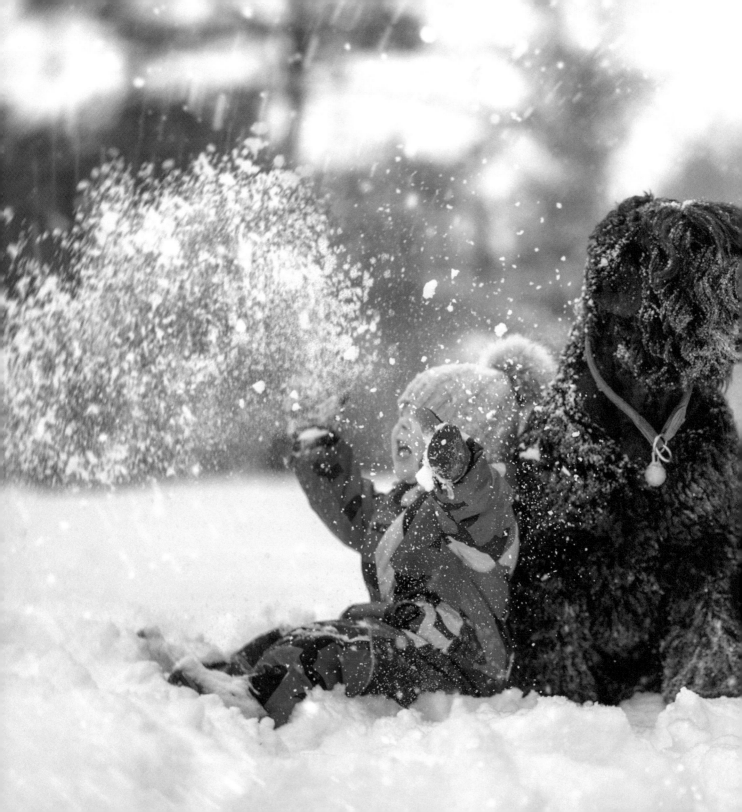

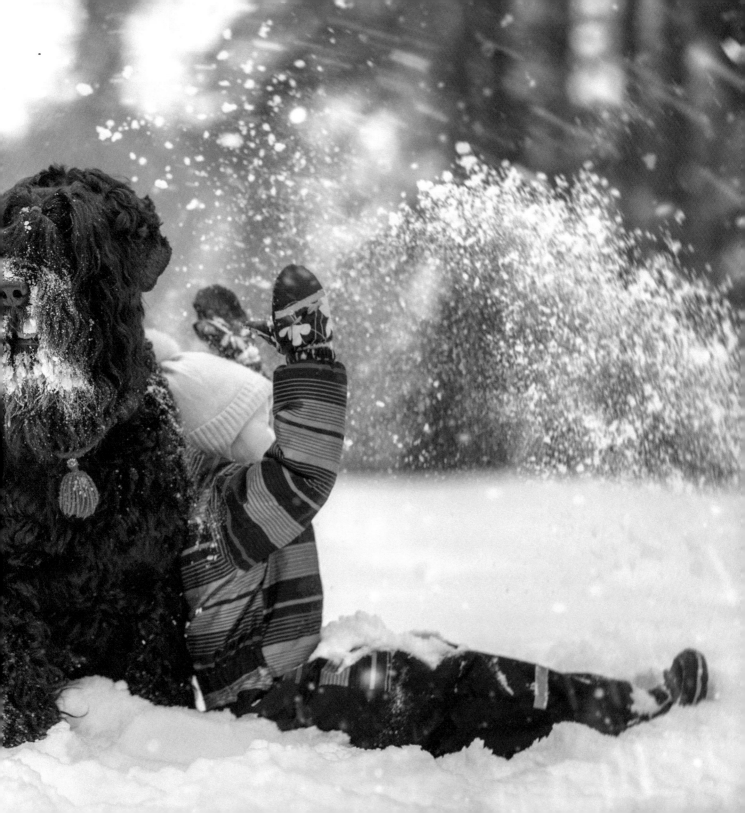

FIRST SNOW

There is frost this dusky evening, which is why the ground crunches under the feet of Crispy the Briard as he returns home from his walk.

Crispy looks at the sky and then at his five-year-old owner, Gregory. "It's going to snow tomorrow," says Crispy, who has lived through ten winters. Gregory trusts Crispy about everything, since before he could even remember, the wise Briard has known everything. And so Gregory isn't surprised when he runs to the window in the morning and finds the city under a thin blanket of first snow.

Today is a day off, and Gregory quickly eats his breakfast, dresses himself and puts on Crispy's collar, all while parents are still preparing to go out.

Every branch appears sculpted from snow, and the paths look like tunnels of lace. Crispy runs ahead to see if there is any danger, and returns to announce that everything is in order. When Crispy tires, Gregory sits by him, and they take in the snow-covered lake and the forest on the opposite bank. Gregory sees icicles forming on the Briard's beard and eyebrows, but Krispy just grins. "Do you really think I'm cold in this coat?" Krispy says, stretching. "Can we have a snowball fight now?"

But on the car ride home, Gregory is upset. "Crispy, it's getting warmer. All the snow will melt!"

"Yes," Crispy nods. "But new snow will fall soon, and it will stay until the end of the winter." The Briard puts his head on Gregory's knees and yawns. "And we'll have a snowball fight again and ride a sleigh."

"And I want to learn to ski," the boy adds.

"Oh, I'll help you," Crisy says cheerily. "I know how it's done!" Gregory is doubtful, then remembers Crispy certainly knows best. So the next day, after the snow melts, he simply repeats Crispy's words to his mom: "The new snow will fall soon, and it will stay until the end of the winter!"

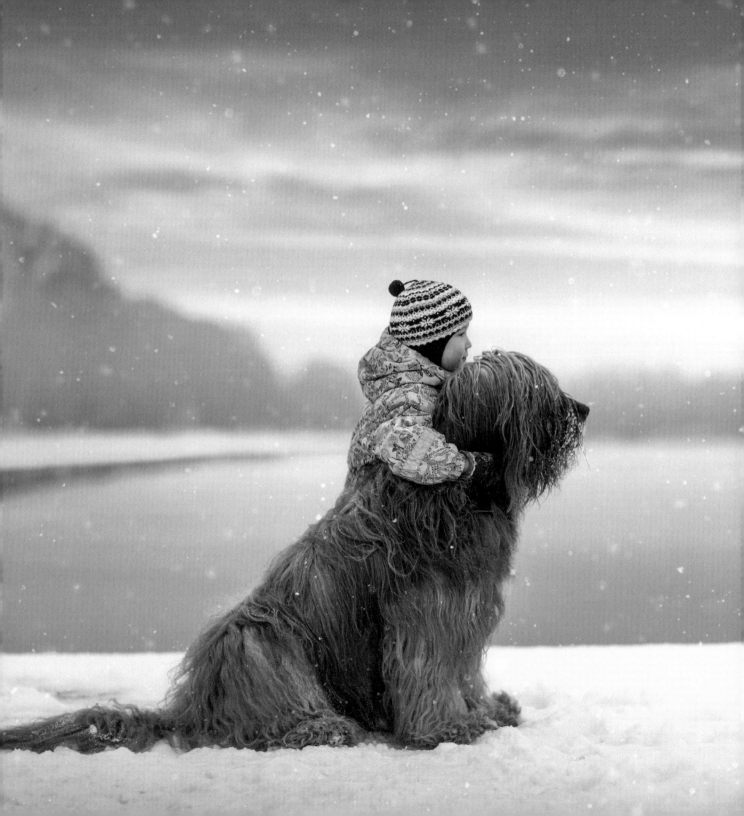

THE SNOW CATCHER

Wolf the Great Dane is bored. He grew up with Shalom the cat and his girlfriend, another Great Dane named Leonella. He helped his owner's daughter finish school and go to university. And now he doesn't care about anyone.

Then in the fall, a neighbor comes to visit with a little boy and his dog. Wolf knows the dog — they have always chatted — but he is very happy to meet this new baby!

The next time Wolf's owner plans to take a walk with the neighbor, Wolf understands what they are talking about. He runs to the door every minute. "Calm down," his owner admonishes. "We'll go soon." But Wolf can't calm down. When they arrive at the neighbor's house, he stands on his hind legs and looks into her eyes, asking, "Is Waldemar coming, too?"

"Yes, of course," the neighbor laughs. "I just have to bundle him up."

Soft snow is falling. Waldemar munches a cookie as Wolf walks beside him, not even tempted by the treat. Sometimes Waldemar gets tired and sits down in the middle of the sidewalk. Wolf just waits patiently while the boy rests.

Waldemar is a very serious little fellow, and to make him smile Wolf's owner tosses a snowball. Wolf jumps up expertly and catches it.

Waldemar laughs. Wolf continues to catch his snowballs, watching Waldemar out of the corner of his eye. Will he laugh again?

Suddenly, the big black Great Dane isn't bored anymore.

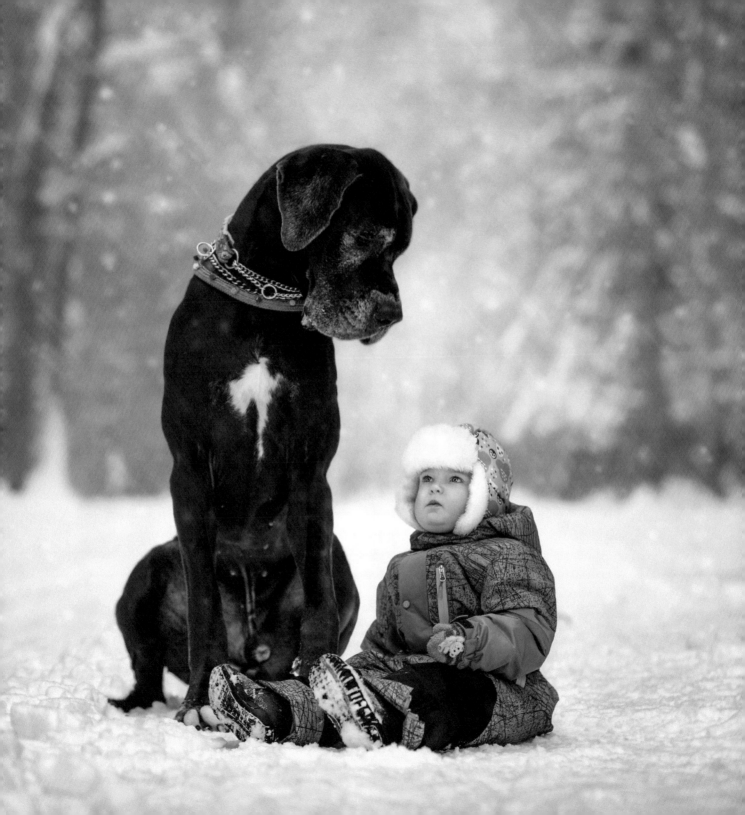

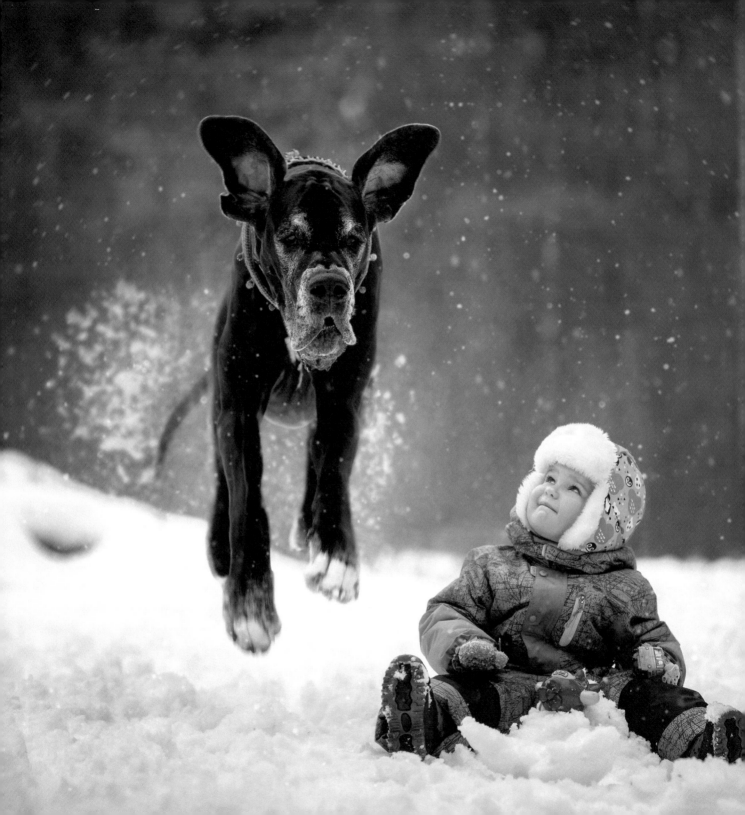

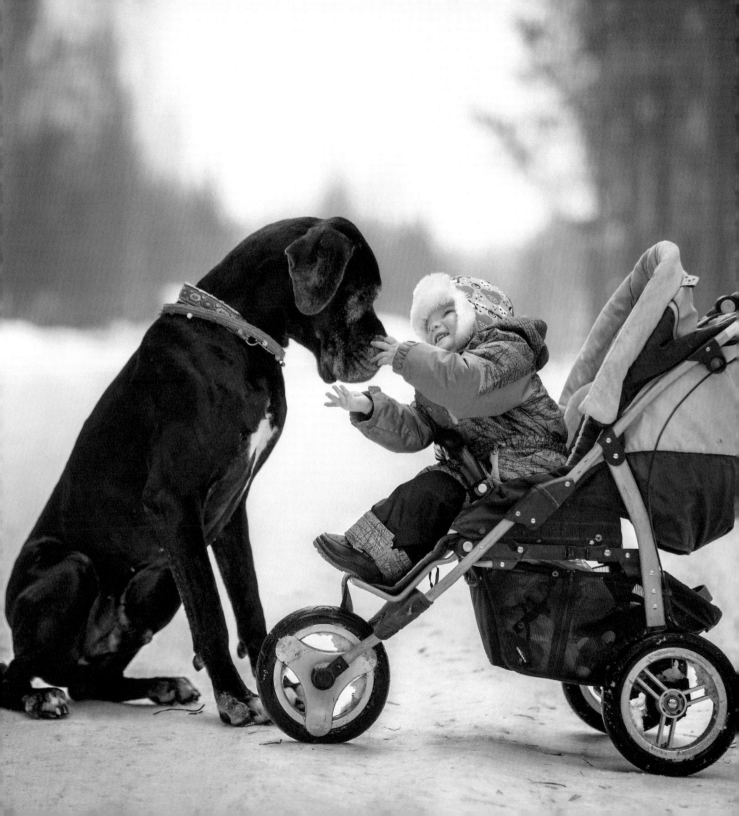

PARALLEL TRACKS

The frosty, sparkling winter has come into the city. A boy named Cyril and a dog called Yarik run along the snow-covered path of a city park.

Cyril is five years old — a wonderful age when children do not readily understand the language of adults, but can easily talk to the birds outside the window, to the cats on the porch, and, of course, to such a wonderful dog in the park.

Yarik is young, too, although he was born a serious watchdog, and that's the kind of dog he is: He is a Moscow Watchdog, little known outside Russia, but bred there to evoke the look of a Saint Bernard with a bit more guarding ability. Despite his job description, more than anything else, Yarik likes to have fun and run with friends.

Cyril freezes in delight when he first sees the large shaggy dog, as if from a Russian fairy tale.

"I would love to have a dog like this one," Cyril thinks, and he goes to meet his new friend.

"Hello! Who are you and where are you from? What is your name?" he asks the red-and-white-coated dog breathlessly. "I'm Cyril, and I'm five years old, I love to run, jump ... Did you see that icy hill over there?"

The dog is happy – he likes hanging out with kids. "Hello there!" he says in a voice no one but Cyril can hear. "I'm from the Tsarskoselskaya homestead, my name is Yarik, and I came here for a walk. I also love to run and jump! Let's climb the hill!"

"Hooray!" Cyril shouts. "Let's climb the hill!"

And then, merrily, the two run toward winter — and friendship.

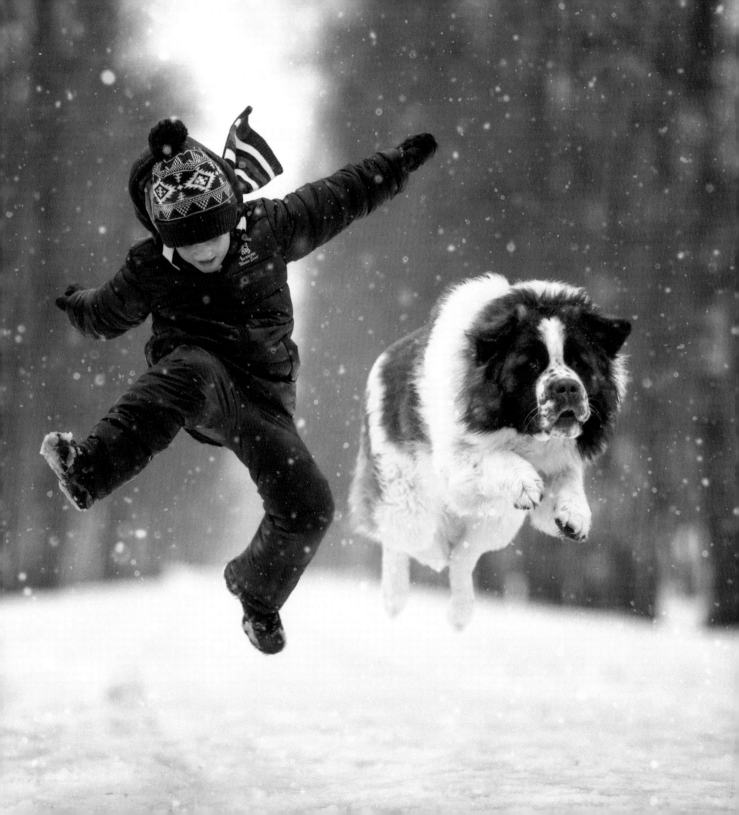

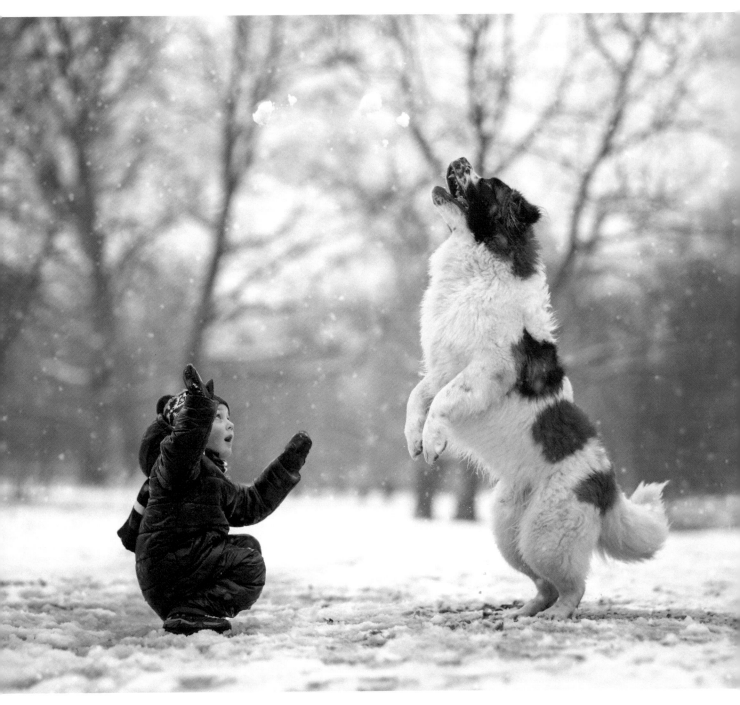

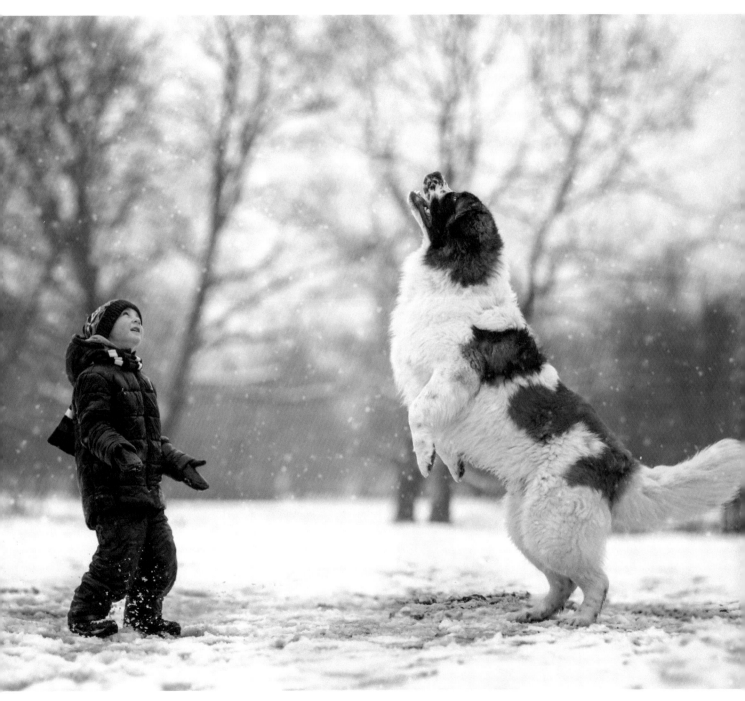

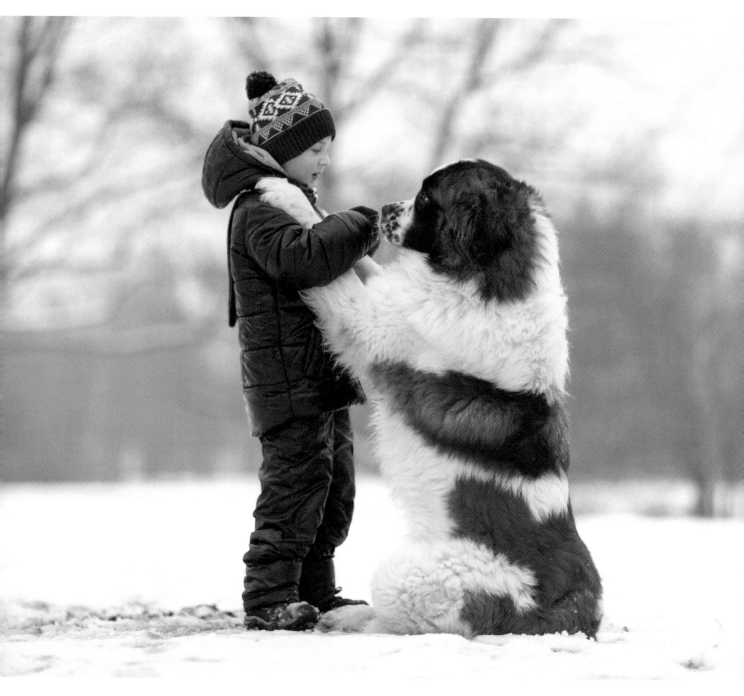

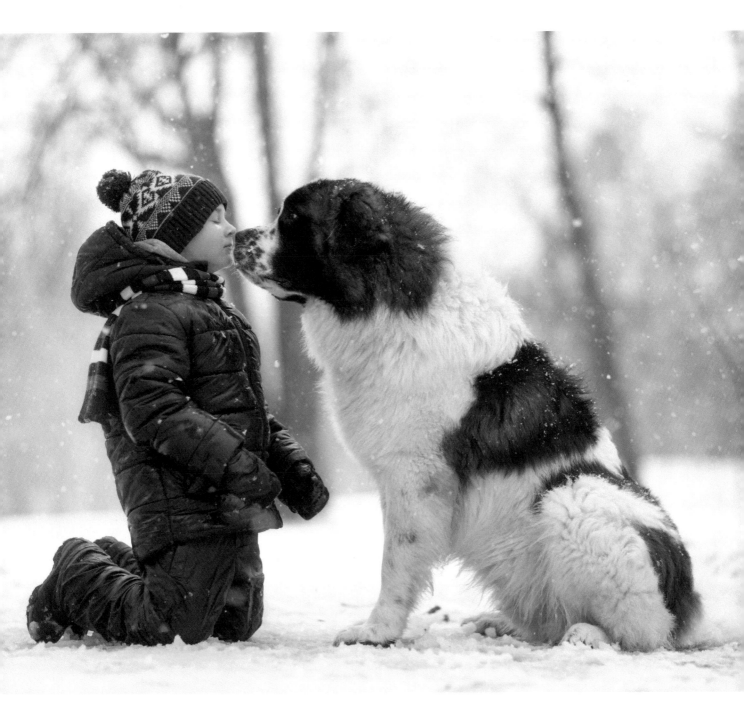

STAR POWER

This morning Marusya has lost a star — the star that sparkles with such joy and happiness through the window of her bedroom on winter evenings.

"What if it fell into the forest and got lost there?" Marusya thinks. "I should go and look for it!"

But searching for lost stars in the winter forest requires some preparation. Marusya puts on a warm coat and boots, and takes her friend, a white teddy bear. Out in the yard, a large Great Pyrenees dog rolls toward her like a huge snowball.

"Hello, Marusya. Where are you going?" the dog asks.

"I'm going to the winter forest to look for the lost star that shone so beautifully into my window."

"Cute little Marusya," Bradley the Pyrenean dog says, "don't you know that all the stars go to sleep in the morning so they can give us their bright light at night? Only during Christmas do they come down to earth to sit on the tops of Christmas trees."

"Oh, thank you, Bradley, for telling me about the star," Marusya says. "Let's look at the evening sky together tonight and see if it is there again."

When the sun disappears behind the tops of the snow-covered fir trees, Marusya takes a flashlight and goes with Bradley to check whether the star is in its place. Everything is exactly as the dog says: Marusya's star is shining brightly.

And in the morning when Marusya comes into the living room, she sees that her star is shining on top of the Christmas tree, too.

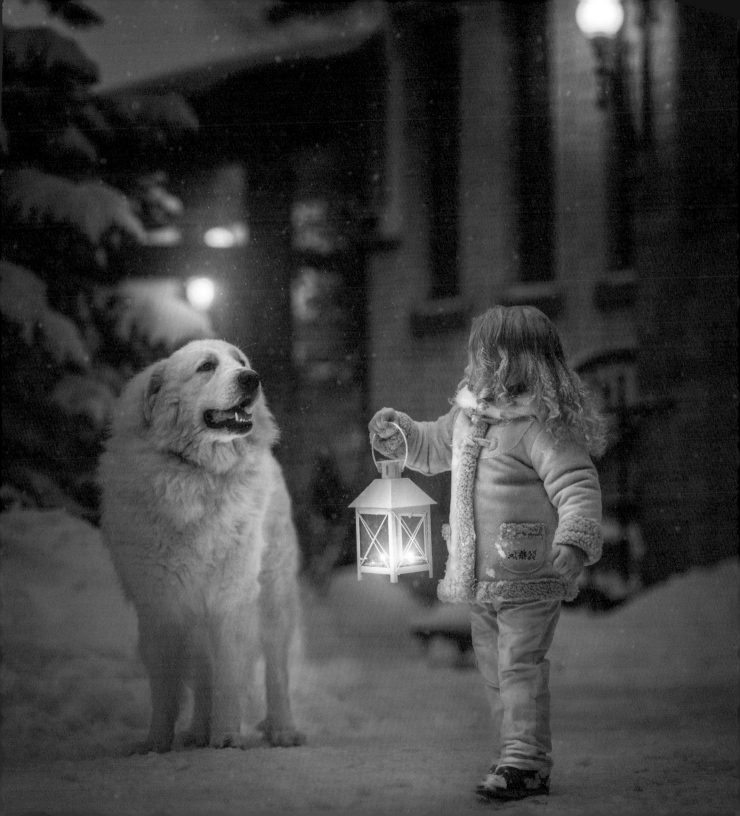

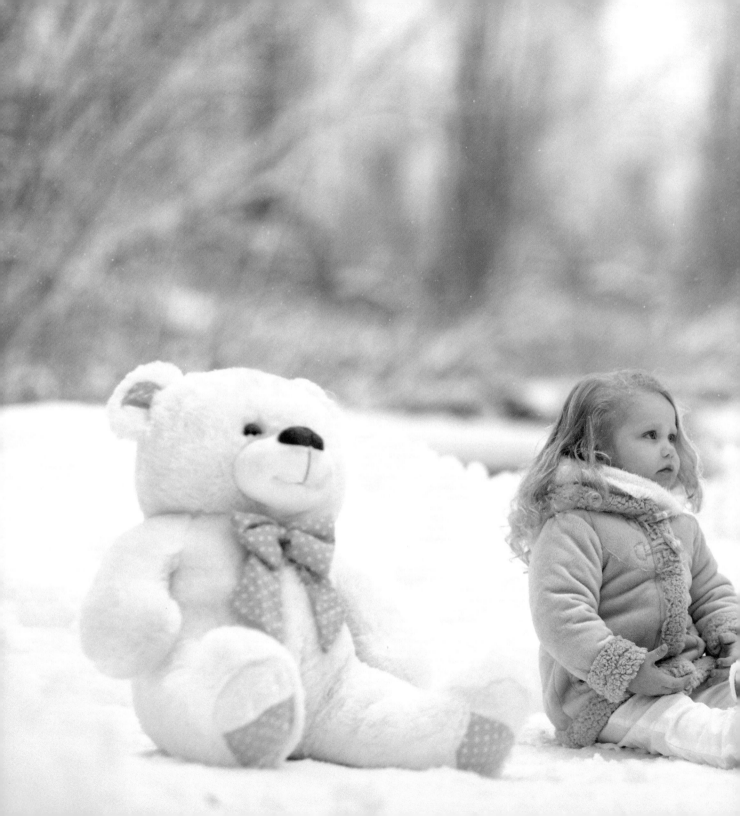

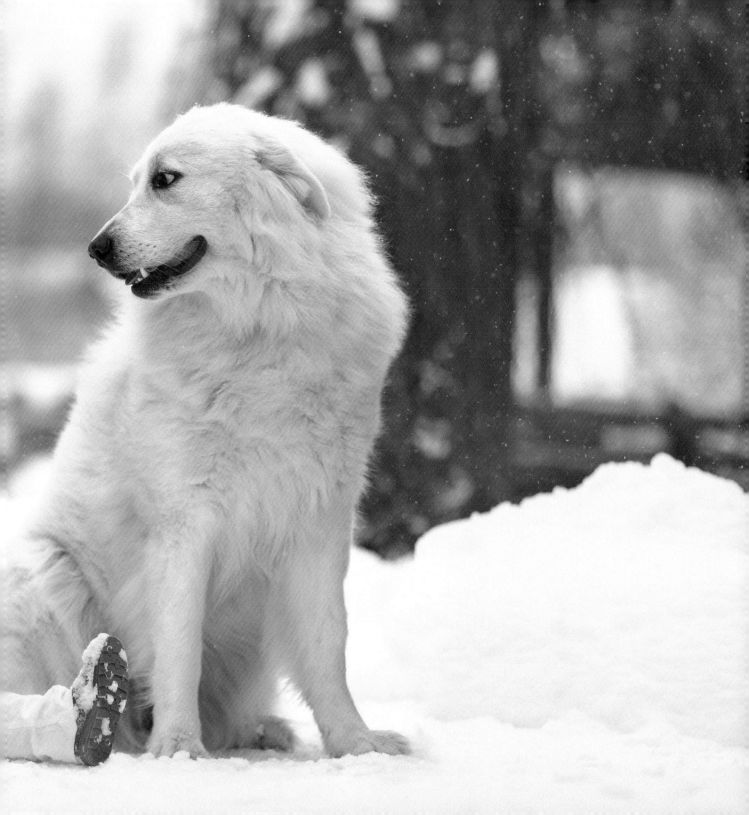

TIMELESS

"Do you know that tomorrow I'm going to take some pictures?" three-year-old Arina asks her brother Arthur. "That's what Mom said!"

"Oh, I know about it," smiles her brother. "But do you know who is going with you?"

The girl squints slyly and replies immediately, without waiting for an answer. "Dia and Marie!"

Later, Arina helps her mother groom the two Tibetan Mastiffs. "Stand still and don't move, or I'll comb only one side of you," Arina cautions Marie as she combs the dog's shiny, long fur, proud that she has been entrusted with such an important task. "You are so beautiful!"

The next morning, the tall man with the huge camera who invited them to the shoot arrives a little early. Andy smiles so disarmingly that Arina decides to ask, "What should we do?"

"What would you like to do?"

"I want to run!" Arina exclaims, bouncing to the beat of a cheerful melody she has been singing since morning. "No, I mean, Dia and Marie want to run!"

"That's wonderful! So, you should run!"

Arina begins to run and play with the dogs, soon forgetting about the time and about the photographer who at the beginning made her feel a little bit shy. So when her parents say it's time to go home, Arina is surprised.

"When are we going to make pictures?" she asks. Andy shows Arina his camera's digital screen, toggling through the hundreds of photos he took. "You all did well, especially Marie and Dia!" he says. "Dogs don't care about time — and when they are having fun, people don't either!"

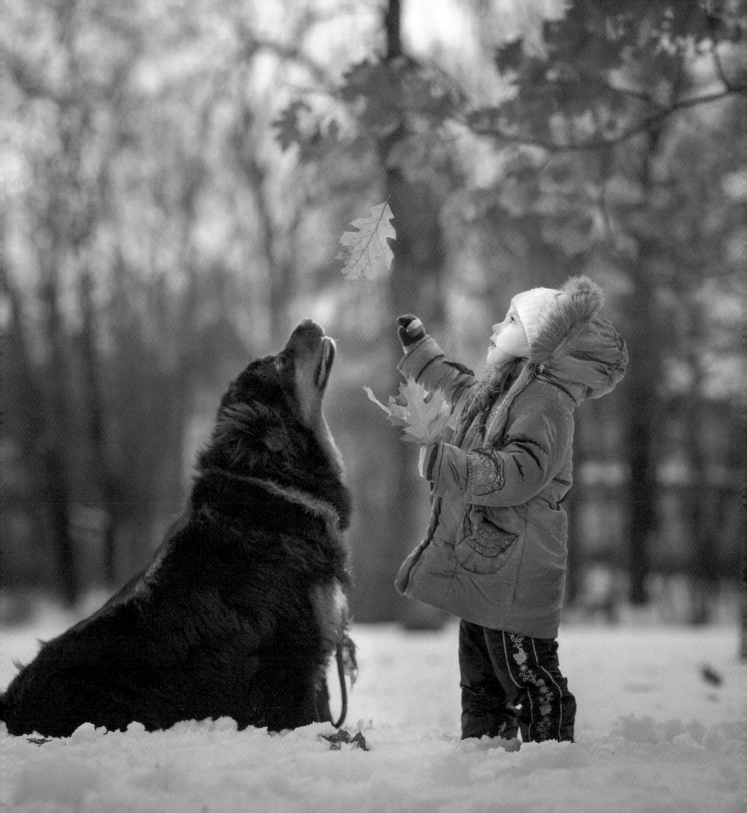

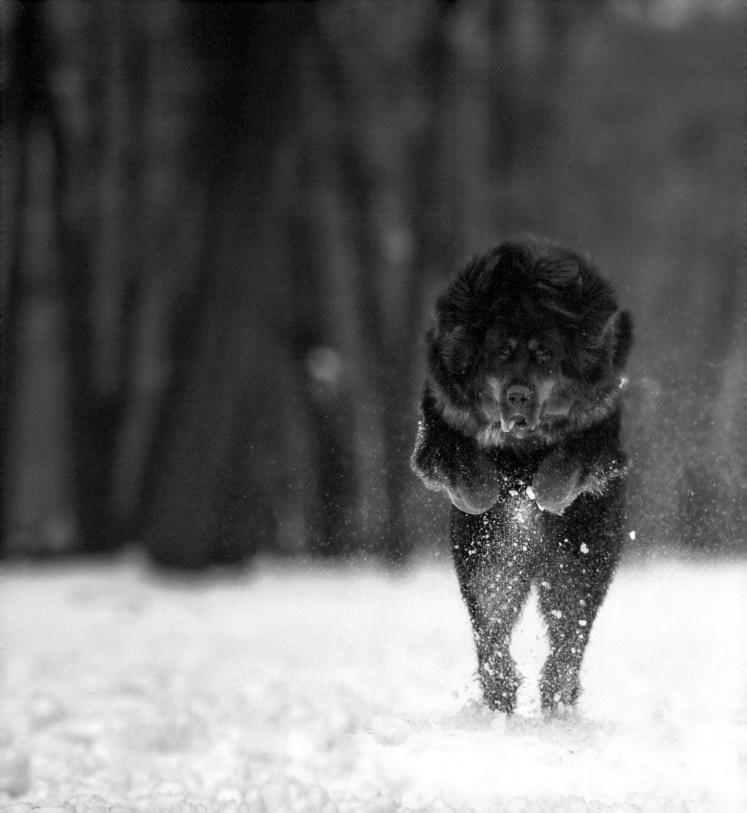

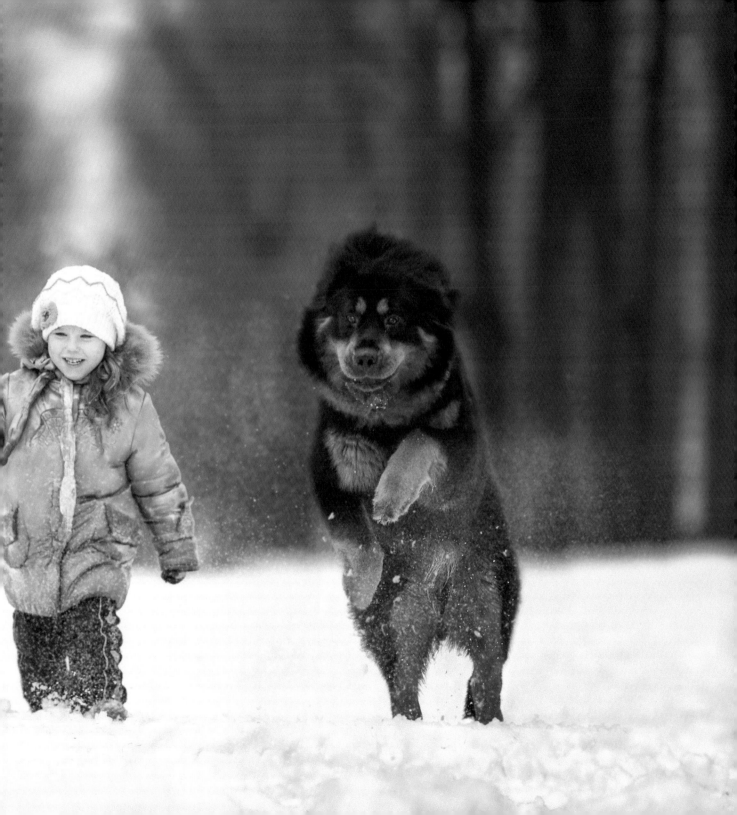

THE TEDDY BEAR

Alice sits on the slide and idly swings her legs. Her mother is solving some very important issues on the cell phone, and for some reason there are no other kids on the playground today.

Suddenly, the bushes crackle, and from their spreading branches a wet brown nose appears.

"Who are you?" Alice asks. "And why don't you come out?"

"I'm a puppy named Harley," replies the brown nose. "Aren't you afraid of me?"

Alice laughs. "Why should I be afraid of a puppy? We have dogs at home, too, but they already had their walks. And I have other Newfoundland dog friends, too — Ringo, Taras, Makar and Kisa ..."

Boldly, the nose moves toward her, and Alice jumps off the slide. "You're so funny! Just like a teddy bear!" As she pets him, Harley happily wags his tail and tries to catch the pompons on her hat.

At this point, at the curve of the path, a motley team appears: two completely black and two spotted Newfoundlands. "Rescue team, at your service!" Makar wails, trying to lick the girl's face.

"Who and what are you going to save?" Ringo asks in surprise, putting his head under Alice's hand.

"We're going to save Alice and Harley!" Makar replies. "From boredom, of course!"

The five dogs and Alice play tag, and have a race to see who can climb the hill faster.

"Will you come tomorrow again?" she asks. "And will the teddy bear Hurley come, too?"

The dogs laugh: No matter how they try to convince Alice that Harley is a baby Newfie, they fail.

"Yes, of course," Ringo promises. "Harley the teddy bear will definitely be with us!"

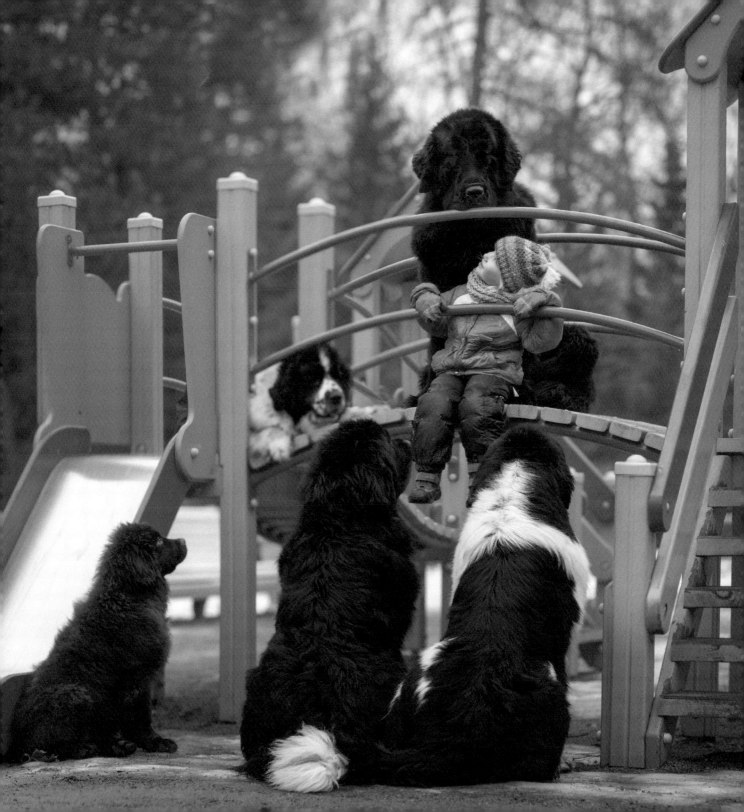

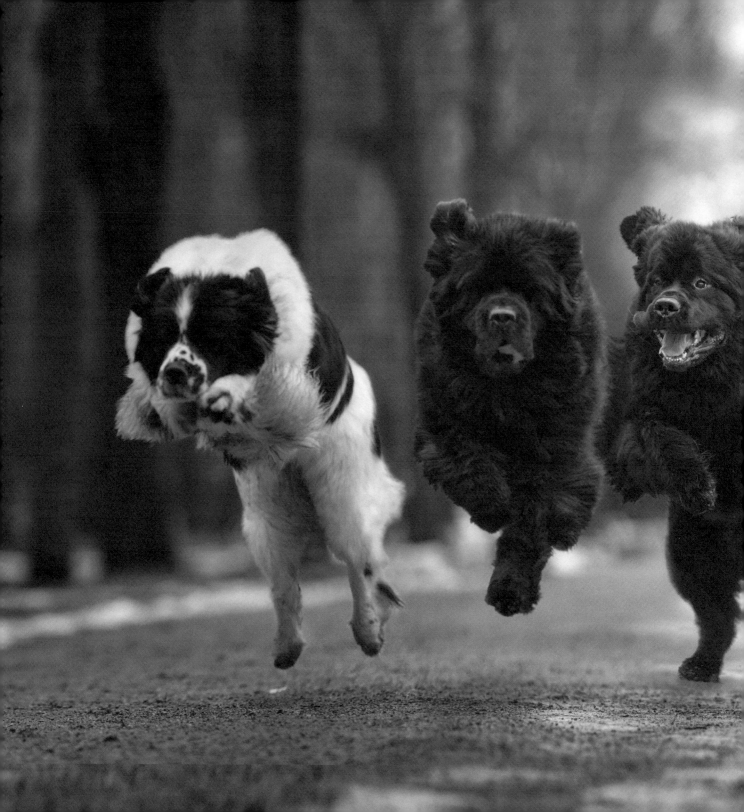

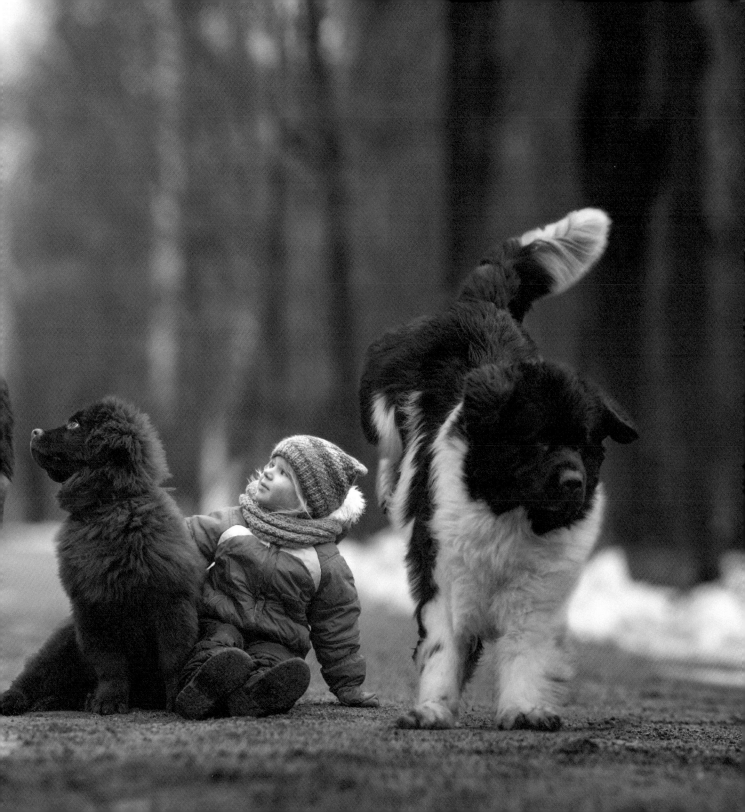

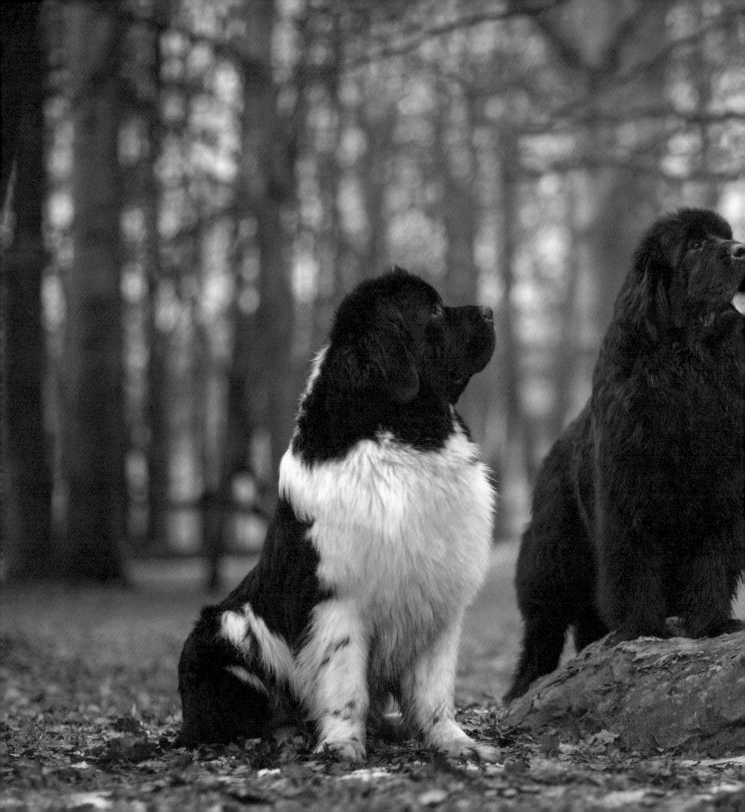

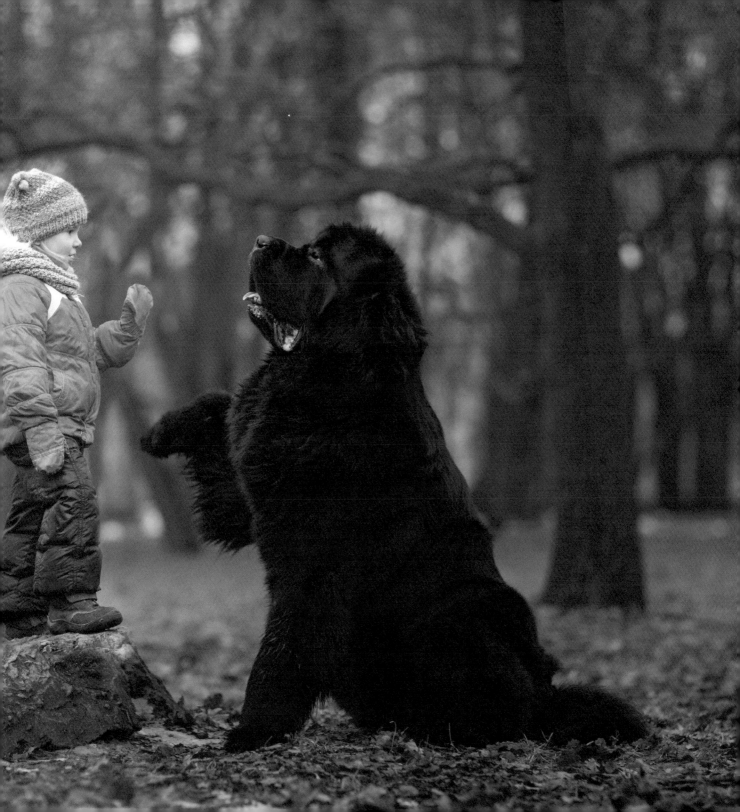

DANCE PARTY

Jay the Ridgeback is running in the snow around her two young owners, Ksenia and Dasha.

Rhodesian Ridgebacks are famous for hunting lions, and there are no lions marauding around St. Petersburg, which shows you how good they are at their job. But in their native South Africa, Ridgebacks had an equally important job: They were professional babysitters, famously patient with children of all sizes.

"My beautiful girls, today we have so many interesting plans!" Jay says. "I'm going to teach you to dance!"

"What about me?" tiny Ksenia asks. "I don't even know how to walk yet."

Jay comes closer and bends down so Ksenia can grab her collar. Dasha helps give her little sister a boost up. "Ksenia, today you will do that, I'm sure! A few years ago, Jay taught me to walk, too."

Holding Jay's collar, Ksenia wobbles for a moment, then extends a leg. "Now the right leg," Jay coaches. "And next it's the left, and then the right again ...Well done!"

Exhausted, Ksenia plops down to rest, and Jay runs for Dasha, who has wandered away, bored.

"Jay, when will we dance?" asks Dasha impatiently.

Beautiful and athletic Jay launches up on her rear legs, much to Ksenia and Dasha's delight.

Inside the warm house, Ksenia continues her walking practice by holding on to the couch while Jay settles down by the fire. The glowing embers warm her right to the bone, just like the blazing South African sun.

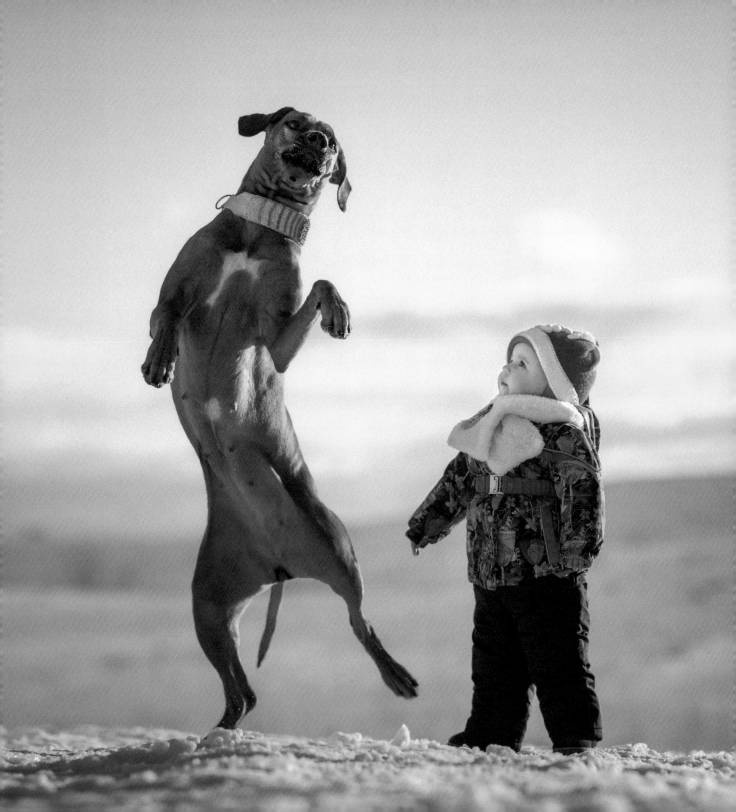

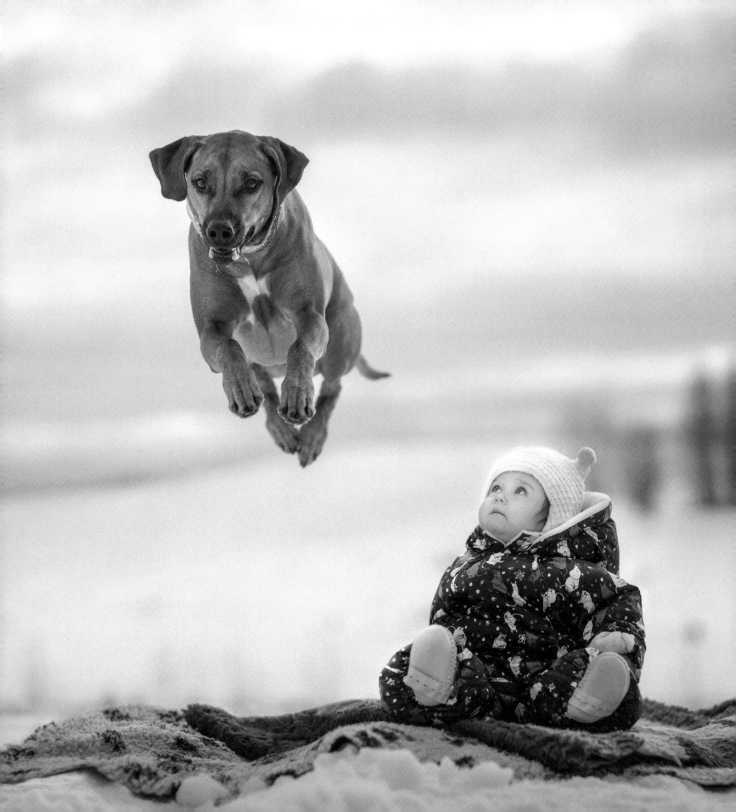

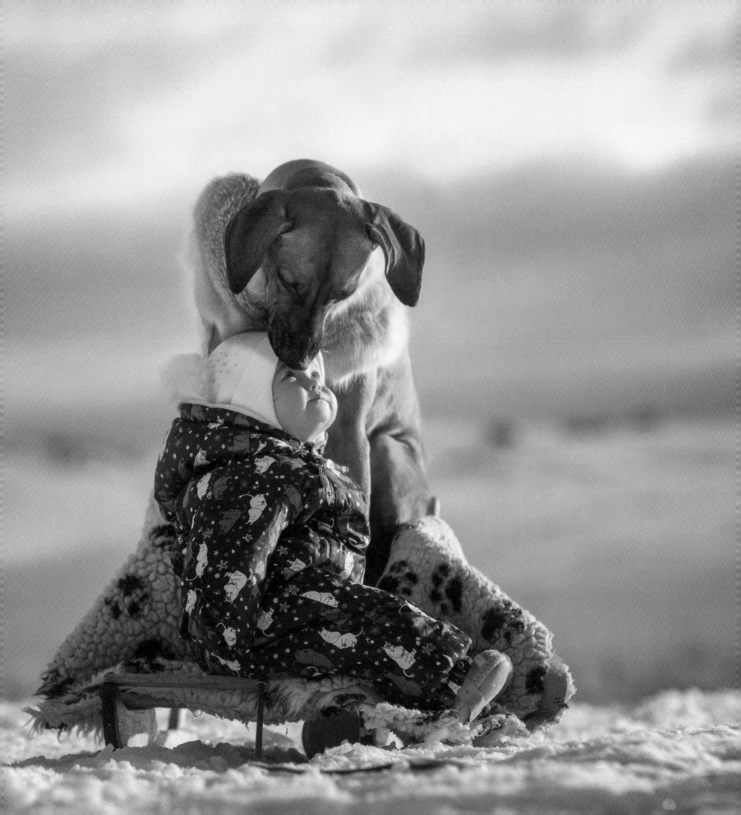

REUNION

Five-year-old Mary was the first person Neil met when his owner brought him home as a tiny puppy. He was a little bit scared, and happy, and curious: What is behind that door? What is in that bowl? Whose sneakers are those? And who is the fluffy hiding under the bed saying, "Meow"?

The Alaskan Malamute puppy heard some voices drift down from the hallway. Then the door swung open, and a charming little girl almost flew into the room. "What a cutie!" she said, scooping up Neil and kissing him. He wagged his tail with all his strength and licked her face.

Every weekend after that, Mary came with her parents to visit her godmother, but Neil knew that she actually came to play and walk with him.

But today, for the first time in two years — which is the whole length of Neil's life — he waits in vain at the gate all Saturday and Sunday for the girl. When his owner calls him to eat, he bolts his food, and then returns to his post. By Sunday evening, it has snowed so thickly the trees and shrubs are covered in minutes. Snowdrifts accumulate on the back and shoulders of motionless Neil.

"You're so silly," smiles his owner. "Mary went on vacation, but next weekend she'll be back!" Neil wags his tail hopefully, raising clouds of snow.

Sure enough, on Saturday morning, he hears the front door's familiar creak.

"Mary, so much happened while you were away!" he says on their walk. "Our cat turned over the flowerpots on the windowsill. And the raven, the one who eats from my bowl, came with her friend! She said the other crows kicked her out of the nest, and now she has nowhere to live. So now *two* crows are eating from my bowl!"

"You've grown so big," Mary laughs. "But still … a cutie!"

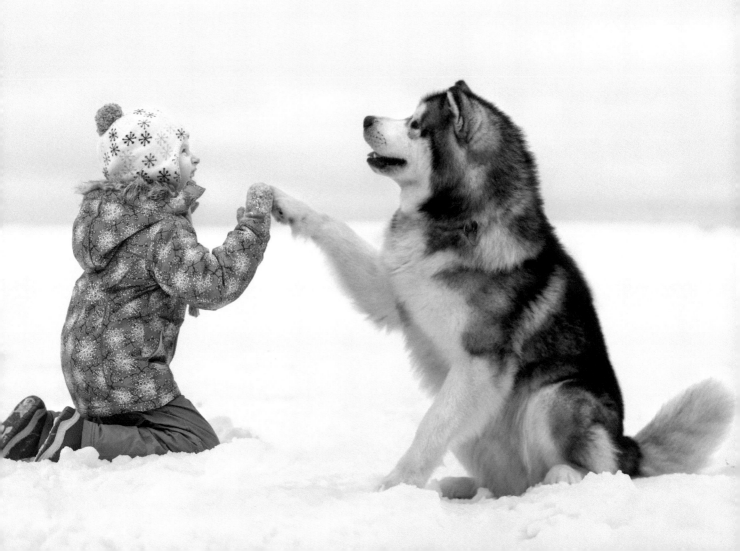

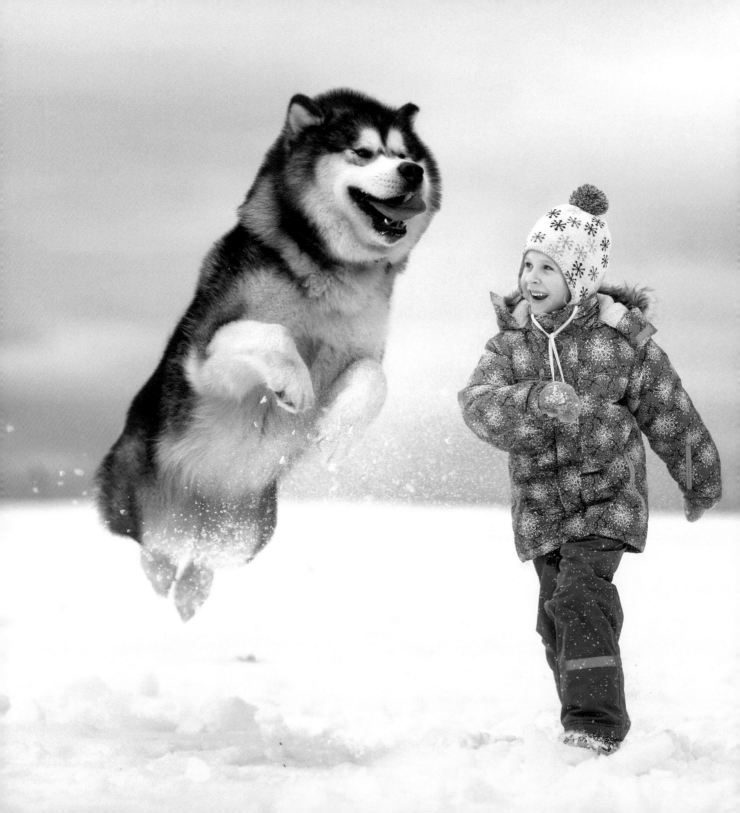

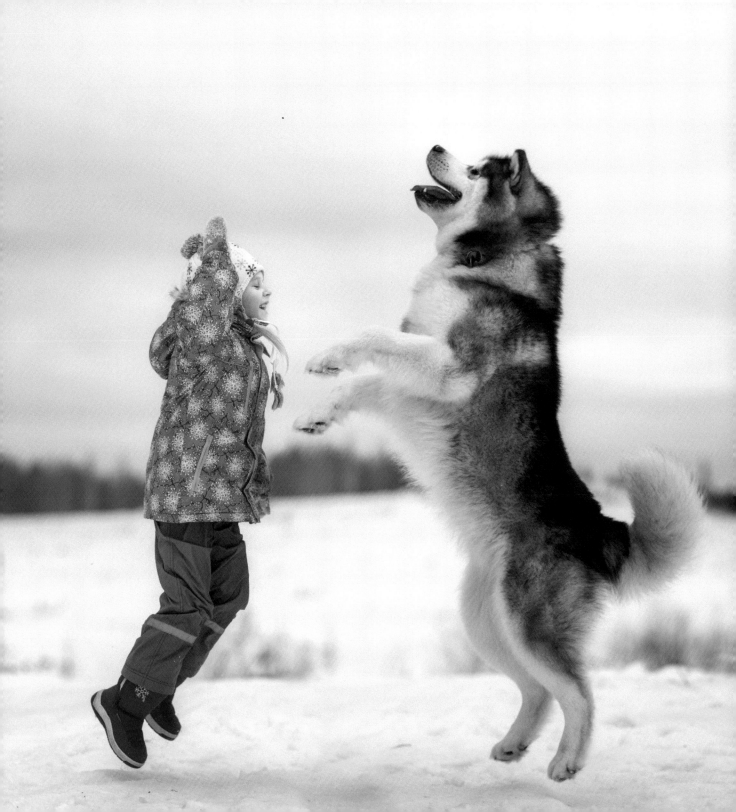

FULL CIRCLE

Our Alice is growing up: It seems like only yesterday that she was toddling around. And now she is running and jumping.

These days when Alice goes out for a walk, it's her job to help Sean get ready. She puts on his collar, snaps on the lead, and makes sure her parents remember his treats and toys.

"What a big girl you are!" her parents say.

"No!" Alice corrects them. "Sean is big and I am small. When I get to be as large as Sean, then I'll be big!"

On this winter walk, Sean is jumping and dancing, infecting everyone around him with his special brand of joy. As he and Alice run among the trees, Sean jumps in and out of snow drifts, so fast that it seems he is flying, not running.

Alice can't keep up. She not only wants to run, but to fly through the winter forest just like her joyful Great Dane does.

Sean isn't a horse, and Alice can't ride him, but he can pull a sled.

So now the friends rush through the forest again. But Sean in his handsome harness runs carefully, choosing a track. After all, no matter how big Anna gets, he is still her protector.

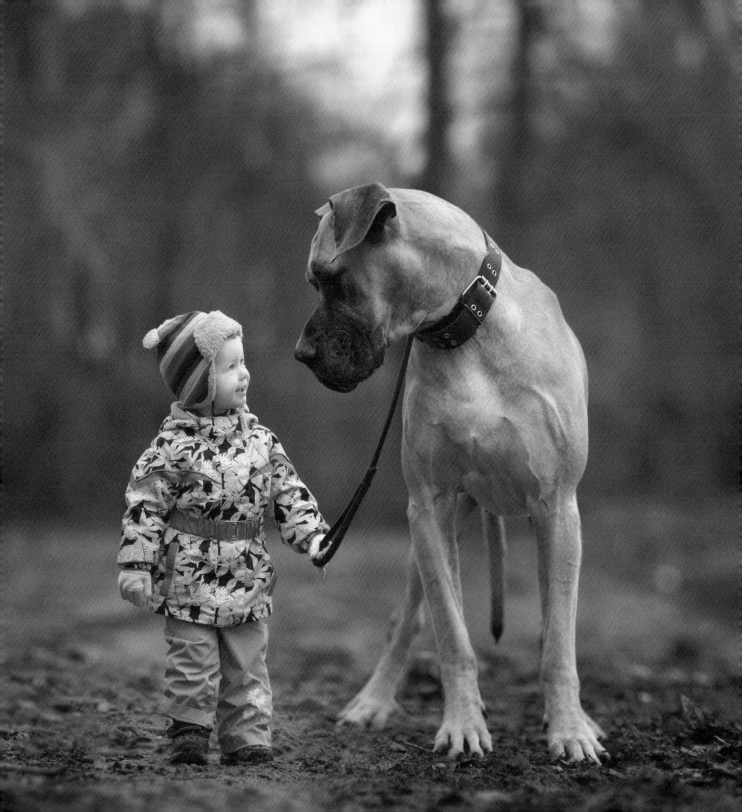

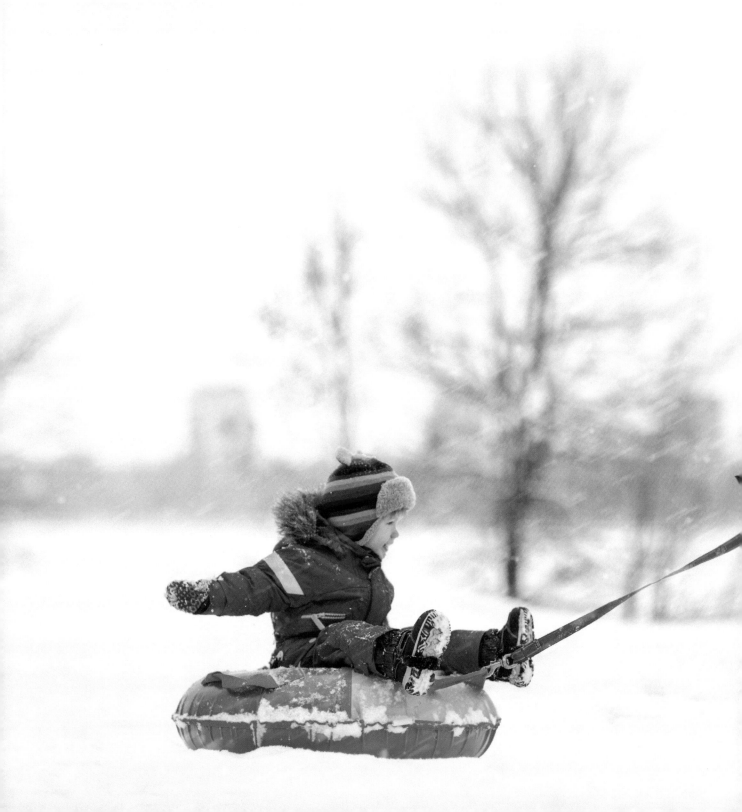

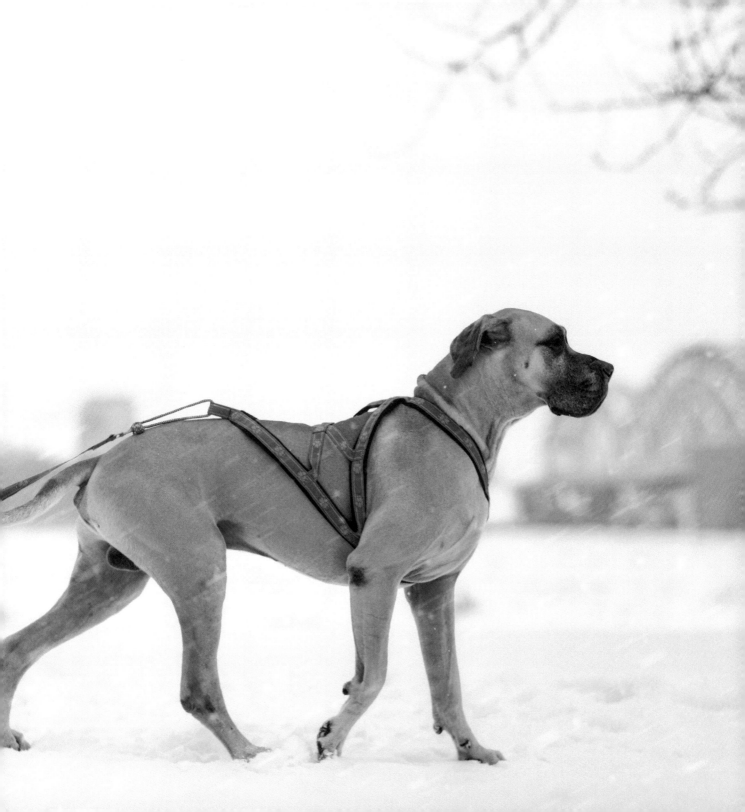

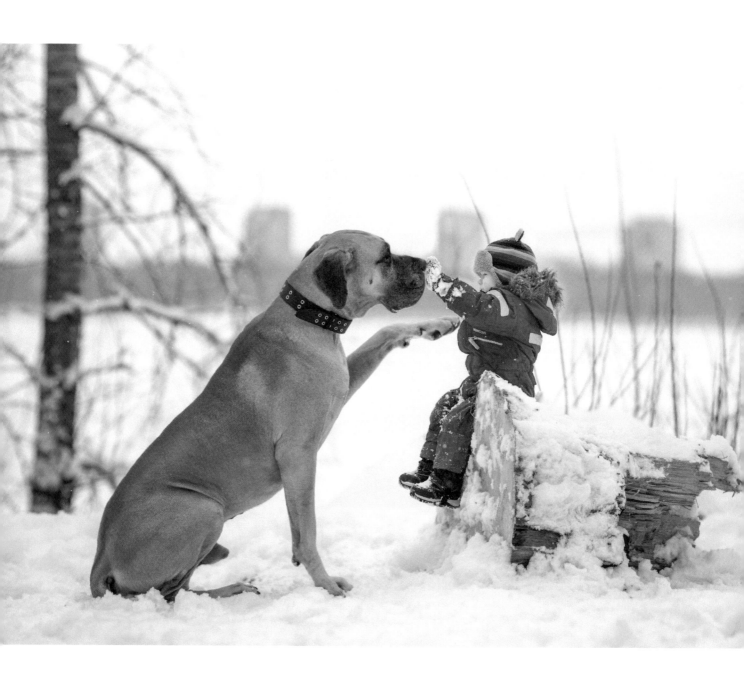

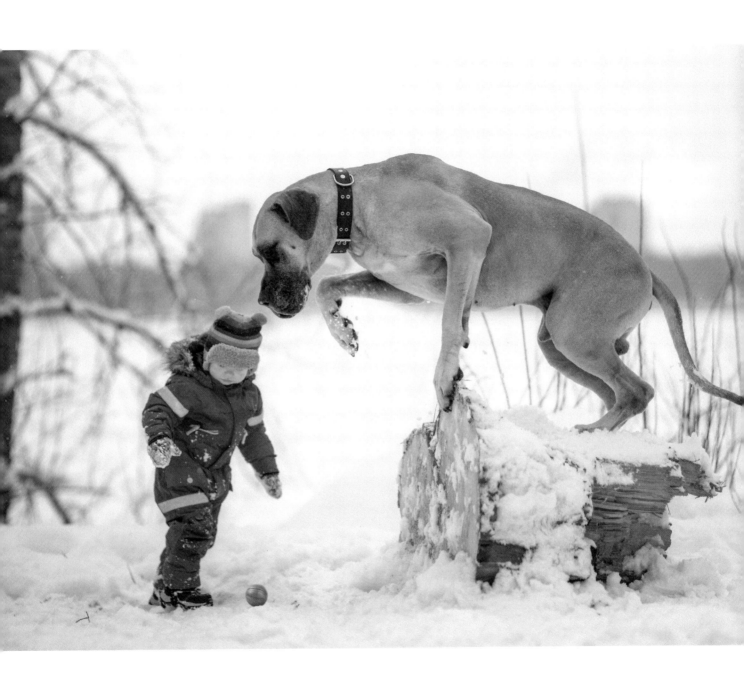

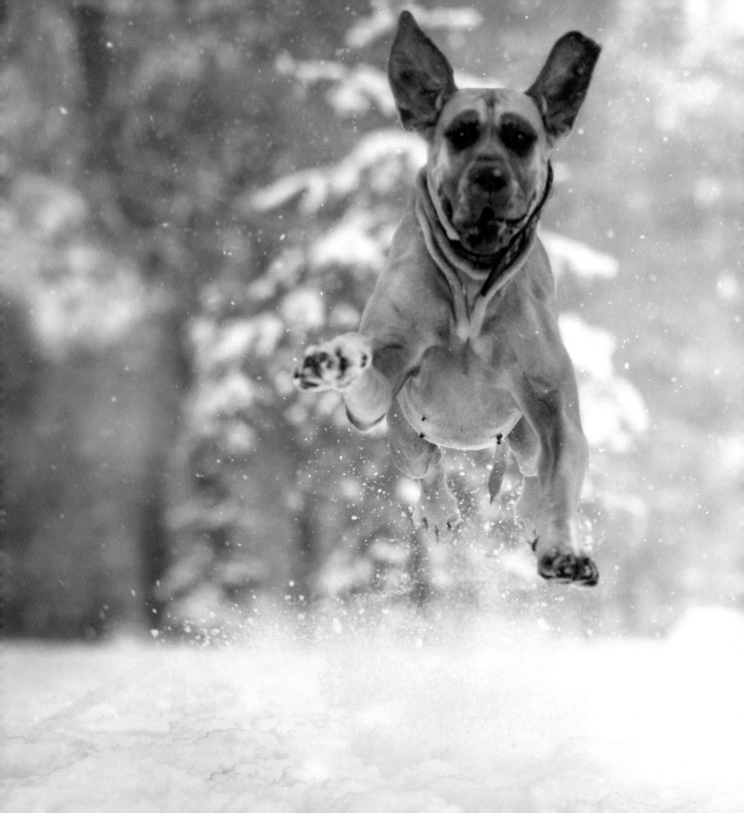

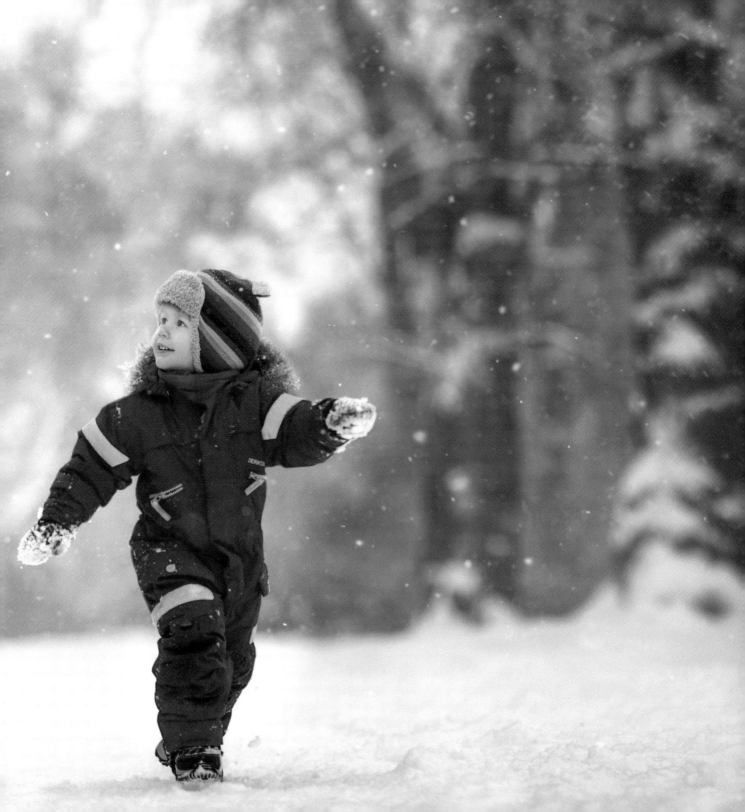

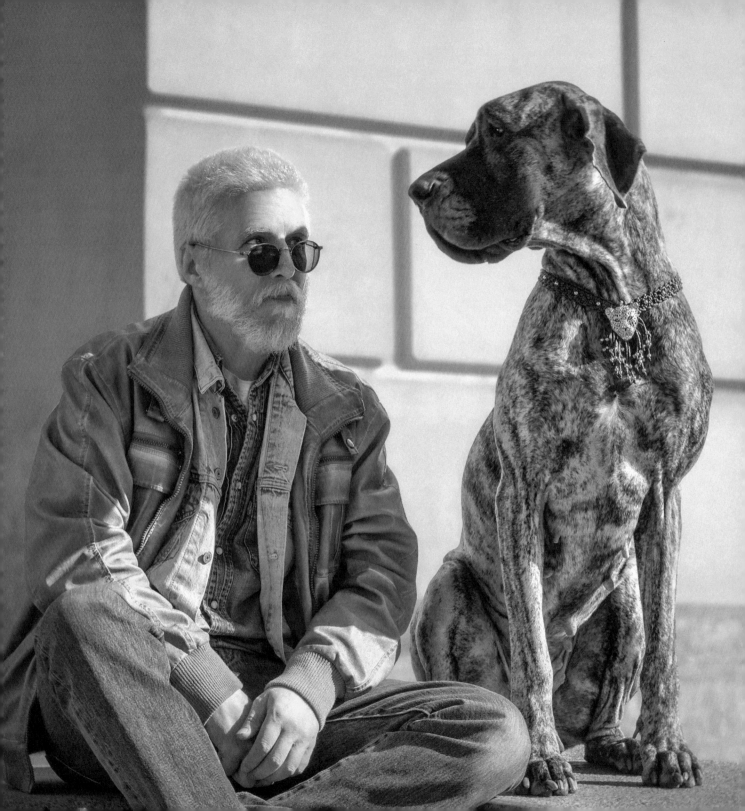

ABOUT THE PHOTOGRAPHER

More than 25 years ago, a long-haired Saint Bernard came into Andy Seliverstoff's life, and things were never quite the same again. Because dogs never live as long as we want them to, Andy eventually found himself without an industrial-sized mound of fur at his feet. That's when the first Great Dane arrived at his family's home in Saint Petersburg, Russia — and he's had one ever since.

The dogs also led Andy to his career as a professional dog photographer. For the last decade, he has been a fixture at major dog shows throughout Russia and Europe, where he photographs big-winning show dogs and the people who love them.

The main goal of Andy's *Little Kids and Their Big Dogs* photo shoots was not just to create beautiful pictures, but to capture and transmit the state of endless joy and mutual confidence between the children and the animals.

A second *Little Kids and Their Big Dogs* book, featuring new faces of both species, is planned for 2017 from Revodana Publishing, as is a stunning calendar and greeting cards.

In the end, Andy hopes the photos convey this important message: Love for dogs and children makes people kinder.

For updates on Andy and his ongoing *Little Kids and Their Big Dogs* project, visit www.revodanapublishing.com.

Great Dane lover Julia Veshkelkaya (above) wrote the book's text, and Newfoundland fancier Katarina Zaslavskaya (below) translated it.

MORE BIG-DOG BOOKS FROM REVODANA PUBLISHING

The Leonberger: A Comprehensive Guide to the Lion King of Breeds

The Official Book of the Neapolitan Mastiff

The Afghan Hound: Interviews with the Breed Pioneers

The Best of Babbie: The Wicked Wisdom of Babbie Tongren,
the Afghan Hound's Sharpest Wit

Your Rhodesian Ridgeback Puppy: The Ultimate Guide to
Finding, Rearing and Appreciating the Best Companion Dog in the World

ESPECIALLY FOR CHILDREN

Peyton Goes to the Dog Show

How the Rhodesian Ridgeback Got Its Ridge

CPSIA information can be obtained at www.ICGtesting.com
Printed in the USA
LVIW01n1058100217
523866LV00009B/21